P9-DCP-320

ALSO BY JAMAKE HIGHWATER

THE SUN, HE DIES: The End of the Aztec World (novel)
JOURNEY TO THE SKY: Rediscovering the Maya (novel)
ANPAO: An American Indian Odyssey (novel)
I WEAR THE MORNING STAR (novel)
SONG FROM THE EARTH: American Indian Painting
RITUAL OF THE WIND: North American Indian Ceremonies and Dances
FODOR'S INDIAN AMERICA: A Cultural and Travel Guide
DANCE: Rituals of Experience
MANY SMOKES, MANY MOONS: An American Indian Chronology
MASTERPIECES OF AMERICAN INDIAN PAINTING (8 folios)

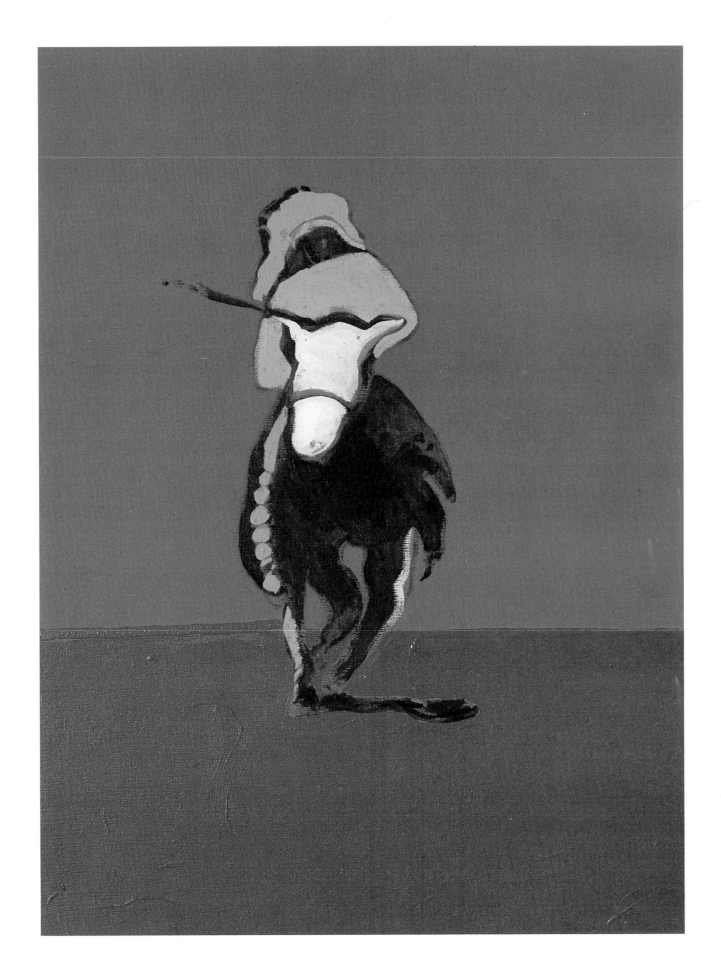

Fritz Scholder: *"Indian Rider,"* 1974; acrylics on canvas; 40 × 30 in.; courtesy
of the artist.

THE SWEET GRASS LIVES ON

LIVES ON

FIFTY CONTEMPORARY NORTH AMERICAN INDIAN ARTISTS

JAMAKE HIGHWATER

LIPPINCOTT & CROWELL, PUBLISHERS NEW YORK

Portions of this work originally appeared in somewhat different form in *Song from the Earth: American Indian Painting* and *American Heritage.*

THE SWEET GRASS LIVES ON. Copyright © 1980 by Jamake Highwater. All rights reserved. Printed in the United States of America. No part of this book may be used or reproduced in any manner whatsoever without written permission, except in the case of brief quotations embodied in critical articles and reviews. For information address Lippincott & Crowell, Publishers, 10 East 53rd Street, New York, N.Y. 10022. Published simultaneously in Canada by Fitzhenry & Whiteside Limited, Toronto.

FIRST EDITION

Designed by Ginger Legato

U.S. Library of Congress Cataloging in Publication Data

Main entry under title:
The Sweet grass lives on.
 Bibliography:p.
 1. Art,Indian. 2. Art, Modern—20th century
—United States. I. Highwater, Jamake.
N6538.A4S95 1980 709 ' .2 ' 2 80–7776
ISBN 0–690–01925–4

80 81 82 83 84 10 9 8 7 6 5 4 3 2 1

IN MEMORY OF TWO WHO ARE GONE

Yeffe Kimball (Osage, 1914–1978)
T. C. Cannon (Caddo/Kiowa, 1946–1978)

I dream of a great breadth of Indian art that ranges through the whole region of our past, present, and future . . . something that doesn't lack the ultimate power that we possess. From the poisons and passions of technology arises a great force with which we must deal as present-day painters. We are not prophets—we are merely potters, painters, and sculptors dealing with and living in the later twentieth century!

—T. C. CANNON

CONTENTS

Author's Note 11

THE ART
Rituals of the Eye 15

THE ARTISTS
Alvin Eli Amason 43
Robert Annesley 45
Samuel Ash 47
Asa Battles 50
Jackson Beardy 52
Delmar Boni 55
Bennie Buffalo 58
T. C. Cannon 60
Don Chunestudey 65
Dawakema (Millard Lomakema, Sr.) 67
Phyllis Fife 71
Harry Fonseca 74

Carl Gawboy 77

Bill Glass, Jr. 82

Ric Glazer 84

Henry Gobin 86

R. C. Gorman 89

Ha-So-De (Narciso Abeyta) 92

James Havard 96

Joan Hill 98

Homma (Saint Clair Homer II) 100

Rance Hood 102

John Hoover 105

Allan Houser 109

Oscar Howe 114

Doug Hyde 119

G. Peter Jemison 122

Goyce and Joshim Kakegamic 125

Yeffe Kimball 127

King Kuka 130

Frank Lapena 132

Harold Littlebird 135

Linda Lomahaftewa 137

Lomawywesa (Michael Kabotie) 141

George C. Longfish 144

Donald Montileaux 146

George Morrison 148

Norval Morrisseau 153

Dan Namingha 157

Michael Naranjo 160

Neil Parsons 162

Carl Ray 164

Richard Ray (Whitman) 166

Kevin Red Star 168

Allen Sapp 170

Fritz Scholder 174

Jaune Quick-to-See Smith 179

Billy Soza War Soldier 181

John J. Wilnoty (Wilnota) 183

Alfred Young Man 186

Selected Bibliography 189

The painters in this visual anthology are "contemporary" both in the fact that they are living* and that most of them are inclined to work in modernist, individualist styles. The sculptors represent a somewhat different focus, since not all of them are living and many of them are—or were—Traditional artists. Most of the seminal sculptors are nonetheless included in order to provide a rare profile of North American Indian sculpture and its major proponents and innovators.

The aim of this collection of Indian art is to be representative rather than inclusive. Though merit and imagination have been the basis for the selection of the works reproduced, there is also a conscious effort to demonstrate the latitude of Native American visual imagination and achievement and to represent a wide geographic spectrum of artists from most regions of North America. An effort has been made to mention in the introduction the creative activities of important artists who, for various reasons, could not be included in this collection.

The biographical notes are drawn, often verbatim, from materials supplied by the artists. Where photographic portraits or

*Except for T. C. Cannon and Yeffe Kimball, to whose memory this book is dedicated, and Carl Ray, who was recently killed.

specific personal data are omitted, it is either because of Indian taboos concerning privacy or because the artists wished to withhold such materials out of personal conviction. Little interpretation is offered, and only basic information is provided in regard to each reproduced work of art. In the case of artists of pivotal importance, a brief appreciation has been added to the biographical information, in an effort to place them in perspective.

The central purpose of this book is to be a vivid visual anthology—a gallery of the achievements of Contemporary North American Indian artists whose works of art speak for themselves. And though the subject matter and the titles of the works are often remote from Indian imagery and figuration, it seems to me—finally—that an underlying "Indian" mentality may be discovered in all the diversified and brilliant art that fills these pages.

I am deeply grateful to the individuals and institutions who provided some of the illustrations and whose names appear in the appropriate captions. I am also grateful to the many experts, curators, collectors, and gallery people who helped put me in touch with artists and who often supplied the materials required to represent wandering, fleeing, hiding, and otherwise unavailable painters and sculptors. The generosity of four of these people especially deserves my acknowledgment: John Anson Warner, Patricia Janis Broder, Charles Dailey, and Bernard Cinader. I must also take a bit of space to publicly thank my former assistant, Charleen Touchette, whose dedication and energy have made a strong contribution to this book. And finally to my editor, Beatrice Rosenfeld, and to art director C. Linda Dingler, I extend my very genuine praise and appreciation for their help in bringing these striking and exceptional images to a wide audience.

JAMAKE HIGHWATER
PIITAI SAHKOMAAPII (*tribal name*)

Lethbridge
Alberta, Canada
1980

THE ART

RITUALS OF THE EYE

To speak of mystery in terms of mystery.
Is that not content? Is that not the
conscious or unconscious purpose of the
compulsive urge to create?
—Vasily Kandinsky, 1912
On the Spiritual in Art

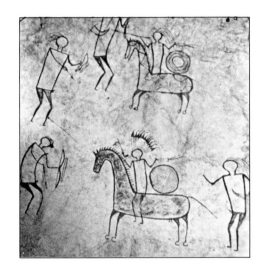

Indian drawing depicting two legs of rider on one side of the horse; attributed to a Sioux warrior, ca. 1850.

The twenty-sixth of February, 1852, was a day filled with wind and snow at Fort Union, near the mouth of the Yellowstone. The Swiss artist/explorer Rudolph Friederich Kurz had come a long way from his homeland in order to observe and to draw the wild Indians of America. What he found in the Northwest was a race of exceptionally refined people whose skills as artists impressed him. "They drew very well indeed for savages," he wrote in his *Journal.* "We must take into consideration," he conceded, "that the human form is not represented in the same manner by all nations; on the contrary, each nation has its own conventional manner."

Kurz recalled one encounter with an Indian "artist" that intrigued him. "While I was sketching one afternoon, a Sioux visited me. To my surprise he brought along two interesting drawings of his own. While I worked he glanced over my shoulder and nodded rather sympathetically. It turned out that he was not at all satisfied with my drawings. He explained to me that he could do better."

With amusement, Kurz provided drawing paper and ink. The Indian began at once to make drawings. After producing a number of very handsome figures, the Sioux drew a man on horseback. Though the animal was depicted from the side, the Indian artist had drawn both of the man's legs on the side of the horse that was in view.

"No . . . no," Kurz hurriedly exclaimed, hoping to correct the error at once. "You must draw only one leg because, you see, the body of the horse conceals the other leg."

Again the Sioux nodded sympathetically at the befuddled Kurz.

To illustrate his argument, the Swiss artist quickly sketched a man on a horse. The Indian gazed at it and then explained that Kurz's representation of a rider with only one leg was "not at all satisfactory."

"This is the way it must be drawn," Kurz insisted. "Only one leg should be visible!"

"But you see," the Sioux said softly, "a man has *two* legs."

To the Indian the fact that the other limb was concealed by the horse's body was not the question. The rule that art must imitate appearances is arbitrary. Indians are not interested in appearances but in essences.

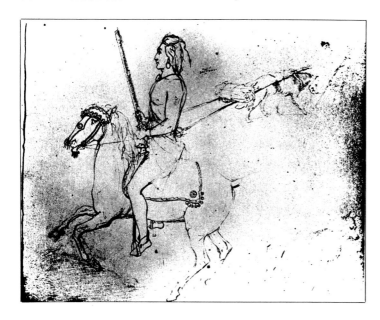

R. F. Kurz's *drawing of an Indian on horseback, ca. 1852; from Bulletin 115, Plate 18, Smithsonian Annual Report, Bureau of American Ethnology, 1937.*

The artists of all races have known for centuries that "reality" depends entirely on how you look at things. Art is fundamentally a way of *seeing*. It is not a stylish and refined decoration, it is not a luxury remote from the necessities of life, and it is not the property of an elite. Art is an essential human process that vividly depicts human diversity. It reminds us that the eye is a real physical and sensual organ and not simply an orifice leading into the brain, where it dutifully delivers pragmatic information.

Artists are not particularly interested in "information." They tend to use the eye in impractical and nonintellectual ways that produce a "marvelous reality." Artists experience objects, but they also experience *greenness, thickness, darkness*. Art is a special way of seeing.

We do not all see the same things. Though the dominant societies usually presume that their vision represents the sole truth about the world, each society (and often individuals within the same

society) sees the cosmos uniquely. At the core of everyone's life is a package of beliefs that everyone learns and that has been culturally determined long before birth. This is equally true for Indians, Europeans, and all other peoples. The world is made coherent by our description of it. How we see things and how we name them permits us to express ourselves, at the same time that it limits what we are able to express to one another. How we see things and what we call them largely determine how we evaluate them. What we see when we speak of "reality" is simply that preconception—that cultural package we inherited at birth.

A sixteenth-century lithograph shows a sailing vessel anchored offshore and a landing party of elegantly dressed gentlemen disembarking from a small landing boat while noble Indians—one conveniently carrying a "peace pipe" for the occasion—stand by to greet the strangers with open arms. It is a familiar depiction of a famous scene from the white man's history of America.

Another drawing—this one made by Choctaw Indian artist Asa Battles—shows an entirely different scene. An Indian gasps in amazement as a floating island covered with odd creatures with hairy faces and tall defoliated trees approaches.

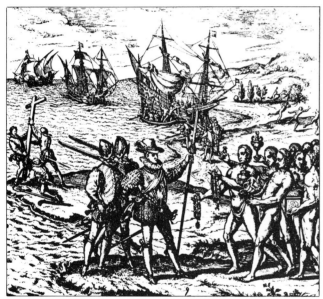 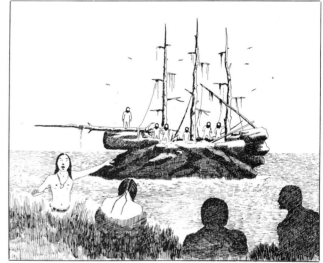

A sixteenth-century anonymous etching (left); Asa Battles: *"Strangers from the Sea," 1974; pen/ink on paper; courtesy of the artist (right).*

The Indians saw a floating island while Europeans saw a ship. And in this curious way one of the fundamental problems of philosophy becomes a cultural issue, for isn't it also possible that another, utterly alien people with a completely different way of seeing and thinking might have seen neither an island nor a ship? They might have seen the complex network of molecules which, science tells us, produce the outward shapes and colors we simply see as objects. In that case, who really sees reality?

We see the world in terms of our own experience of it. Kurz saw one leg while the Sioux artist saw two. We see the world in terms of our cultural heritage. Take, for instance, these eight images of the horse.

Eight images of the horse (above and opposite page, left to right) Howling Wolf: *"Chasing Horses,"ca. 1875, courtesy Mrs. Thomas Curtin and the Northland Press;* George Stubbs: *"Lion Attacking a Horse,"1770, courtesy of the British Museum;* Gilbert Atencio, *"Dance of the Little Horses,"ca. 1955, courtesy of the Museum of Northern Arizona, Flagstaff;* Franz Marc: *"Blue Horse I,"1911, courtesy of the Munich Stadtische Galerie;* Woody Crumbo: *"Spirit Horse,"1945, courtesy of the artist;* Ross Stephens: *"Grazing,"1974, courtesy of the artist;* Oscar Howe: *"Cunkawakan,"1966, courtesy of the University of South Dakota, Vermillion; Anonymous eighteenth-century Chinese "Rider and Horse."*

The way in which an artist sees determines what is painted or sculpted. It also determines whether this art will be traditional or avant-garde. If what the artist sees fits into available attitudes and techniques, he or she will doubtless produce conventional art. But if the artist's vision is not readily expressed in available techniques and media, new materials and techniques will be found, and therefore the work will be progressive or perhaps experimental. Seeing and making art are inseparable activities because technique and content are always inseparable in art—*a technique is itself a way of seeing.* The only function of technique in art is the transformation of a vision into a painting or sculpture.

The complex process by which the artist transforms the act of seeing into a vision of the world is one of the consummate mysteries of the arts, one of the reasons that art is inseparable from religion for most tribal people. A bit less mysterious is the technique by

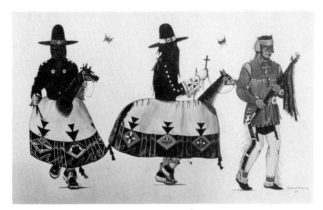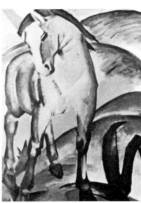

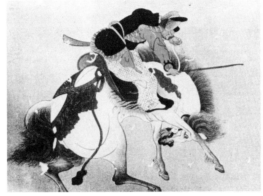

which the vision becomes a tangible art object. Together these two aesthetic activities—envisioning and then engendering a work of art —represent an important and powerful ritual. Art is one of the central ways by which mankind ritualizes experience and gains access to the ineffable—the "unspeakable"—through images and metaphors.

A stable culture is bound together by a mutual and pervasive way of seeing. The way in which a specific people envisions the world permeates every aspect of its life-style, activity, and mentality. One of the elements that make a painting by an Indian an "Indian painting" is the *way* the artist sees—and not simply what is seen. What is "Indian" about Indian painting is not the depiction of *Indian scenes* but the mentality that underlies the whole process by which the work of art comes into existence. And that characteristic mentality is also capable of drastic and modernist change without any necessary loss of its "Indianness." Culture is dynamic. Tradition is also dynamic—not static.

The vision found in contemporary North American Indian art is not exactly the same as that found in the drawings of the Sioux whom Kurz encountered in 1852, nor is it the same as the art of conventional Indians of today who still work in what is called the Traditional manner. A radical change has come about in Indian art,

and the succession of cultural and political events that helped to shape the art of Indian modernists is rooted equally in pre-Columbian and European influences. But there is nothing necessarily ruinous about alien influences in a culture. Indians needn't live back in the fifteenth century in order to remain *real* Indians. Likewise, the impact of oriental modalities on the music of Claude Debussy (which helped produce musical Impressionism) did not make Debussy's music any less European or French; and the influence of French Cubism on the contemporary Sioux painter Oscar Howe (born 1915) does not make his art any less Indian.

Despite the classical ideal of an ultimate and fixed perfection, culture is always dynamic. Interaction between cultures is enriching. Even in the confrontation between two peoples, there is enrichment as long as *assimilation* and *acculturation* remain distinct from one another.

As the Oglala Sioux writer Michael Taylor has pointed out in "Faces and Voices": "During the early decades of this century, private and parochial organizations and the federal government sponsored massive Indian educational efforts, often involving boarding schools. Disruptive of ordinary tribal life and sometimes brutal and insensitive to human needs, the schools notably failed in their initial purpose of eradicating native languages, religions, and customs. What the schools did accomplish was to provide Indian people from divergent backgrounds with a means of communication —the English language."

Students also gained useful skills, a great range of new materials and attitudes they could transform into valuable Indian assets—and also a glimpse of the world beyond the reservations. Today's Indian artist is not simply a product of an ancient culture, as important as that tradition may be. His or her unique vision is the result of both ancient and twentieth-century experiences. And that, finally, is what makes the Indian's work unique and important. Like the Sioux artist who rejected Rudolph Friederich Kurz's concept of reality but readily accepted novelties such as drawing paper and ink from him, twentieth-century Indian artists insist on retaining their Indian mentality but willingly benefit from the ideas, media and technologies of the dominant society. There is simply no question that aspects of modern Indian art are the result of Anglo influences. It is sometimes less apparent, however, that the modern art of Anglos owes a great deal to the influences of such primal peoples as American Indians.

Many of the revolutionary elements of modern art were rediscovered through the work of tribal artists. Maurice de Vlaminck and André Derain altered the development of Western painting when they accidentally came upon African masks and conveyed their deep admiration for them to the young Picasso and Matisse. Henry Moore contributed a major new direction in sculpture through the

documented influence on his work of the carved Chacmools found in pre-Columbian Central America. And the whole thrust of one of America's few indigenous Anglo art forms, modern dance, came about, according to Martha Graham, because she witnessed Pueblo Indian rituals in the Southwest during the late 1920s.

Cultures can enrich each other through their influence on one another. Some see this activity as a sort of cultural plagiarism. As the masterful Hopi Indian artist Fred Kabotie said, "Today there are people who look at my work and they say that I am influenced by Picasso. And I say to them, 'No, it is Picasso who was influenced by the Hopis!'" But this borrowing between different cultures need not be plagiaristic if the influences are transformed by the mentality of a distinctive people into aspects of their *own* experience.

If a celebrated painter makes an impact on successive generations of artists, his or her influence can be seen in galleries and museums. But the influence of American Indians on Anglo art styles is not visible, because until a decade ago a serious recognition of the art of Indians was rare. Few critics, art historians, or ethnologists considered that there was anything about "primitive art" worth knowing.

The assumption seems outrageous today, but in the context of the dominant culture's long-held attitudes toward Native Americans, it was not surprising. Conquering peoples tend to write self-serving history, and American schoolbooks have traditionally portrayed Indians as little more than one-dimensional stereotypes: savages, warriors, and cannibals at worst or, more benignly, perhaps, hunters, pagan ritualists, and skilled horsemen. In matters as lofty as the fine arts, notice generally passed them by. Only the Indians of Mexico and Central and South America who built great ceremonial centers and cities were admired in aesthetic terms—an admiration, incidentally, that failed to spare them from near-annihilation.

Through the nineteenth and early twentieth centuries, there was little Indian painting and sculpture to be seen in galleries and museums. Government policy, mandated by non-Indian society in the United States and ruthlessly carried out by agents, soldiers, missionaries, and teachers, was to assimilate the Indians as quickly as possible. All forms of Indian culture, including tribal art, lore, languages, and even spiritual beliefs, were discouraged and stamped out as impediments to the process of transforming Indians into whites who would meld into the American delusion of an international "melting pot."

Assimilation of Indians, however, was unsuccessful; and when in 1934, under a partial reversal of government policy, the tribes regained many of their cultural liberties, an amazing outpouring of Indian painting and sculpture began to surface, as if an artistic spring had been uncapped. It took some time for this lavish artistic

production to be recognized by the white man, but today the artworks of Indians are accessible and are making an impact at last on those who once very nearly destroyed the cultures from which they came.

No one knows for certain when Indian art began in North America. It is easier to date the artifacts of Middle and South America, because the materials in which those ancient artists worked were durable. Enough, however, remains from the distant past to establish that the artists of North America had been using abstract and geometric imagery for centuries—recording their iconography on rock, bone, painted hides, wood, and pottery and in sand paintings.

Scholars of the nineteenth century believed North America to be a young land, almost entirely lacking in truly aged or exceptional relics. The ancient world of the Southwest was still largely unknown; the Aztec and Maya realms were shadowy regions that were subject to great debate among theologians and historians who were aghast at the notion that whole civilizations might have existed outside the context of biblical genesis. The archaeological impact of finds within the United States was not fully felt until the extensive excavations of the 1930s and 1940s, when a wealth of murals and graphic decoration was unearthed. The belated recognition that rich and complex prehistoric Indian cultures had indeed existed came almost too late. Small amounts of Indian art had been preserved by museums or private collectors, most of them located in Europe, where there had long been a romantic appreciation of the American Indian. Among the most conservative and tenacious tribes, especially in the Southwest, many religious objects, murals, and symbolic images had been hidden from the white man's sight. These precious artworks survived, but a great deal more Indian art of all types had vanished, at the hands of missionaries who regarded the Indians' expressive works as heretical or of laymen who were simply indifferent to it unless it was wrought of precious materials.

Between 1830 and 1850, when artist/explorers such as Rudolph Friederich Kurz, George Catlin, Karl Bodmer, Alfred J. Miller, and Paul Kane were making their remarkable cultural explorations among Plains Indians, the "artists" they encountered were just discovering such European media as paper, ink, crayons, and pencils and were beginning to conceive of themselves as individual creators who signed their works. Before this, "artists" had been anonymous, tribal craftsmen whose "art" existed before there was a name for it, whose efforts were largely collaborative, and whose artistic aims were essentially ritualistic rather than individualistic and expressive.

The modern movement of Indian painting officially began when a group of Plains Indian warriors was imprisoned at Fort Marion in Florida for their military resistance to the U.S. Cavalry. These mounted hunters of buffalo and fierce defenders of their ancient

lands had long painted hide-covered shields, tipi linings, and buffalo robes with icons and personal spiritual imagery, and some of them had also kept pictographic historical accounts. There was hardly a person who was not a painter: the men traditionally created figurative art while the women normally produced abstract and geometric designs.

As these great warriors of the Plains were subjugated by the army and imprisoned far from their ancestral homes, they expressed their forlorn state and loneliness in pictures. Using white men's supplies and drawing in army commissary books, in traders' ledgers, and on lengths of muslin and canvas, the prisoners, in their traditional pictographic styles, created emblems and images of the undying Indian world. This Ledger Art, as it is known, is precious both as history and as fine art, for it reflected many centuries of Indian life-style and events at the same time that it carried Indian artistic sensibility into the twentieth century. It also indicates how brilliantly the native artists incorporated European materials and techniques with their age-old graphic traditions.

About the same time, in the Southwest, Pueblo and Navajo Indians began to experiment with pencils, crayons, and paper. Little is known about these earliest painters, but we possess some of their work, painted on wrapping paper, ends of cardboard boxes, and other scraps. Encouraged by a few sensitive anthropologists and trading-post proprietors, individuals began to emerge as "artists" —a distinction that had not previously existed among Southwestern Indians, for whom art was an intrinsic part of daily life and not the creation of specialists.

Then in 1917 Crescencio Martinez of San Ildefonso Pueblo in New Mexico came to the attention of an archaeological field unit from the Museum of New Mexico, which learned that he liked to make paintings of the secular dances of his pueblo. Less than two

Crescencio Martinez: "Deer Dance," 1917; courtesy of the Museum of New Mexico.

years later this pioneer of modern Indian watercolors died of influenza, but other young Indians took up his work, and they gradually evolved a distinctive idiom of Puebloan art. These young artists were often referred to as "self-taught," but in fact they were products of their own culture's "academies," which passed down ancient ideals and techniques through example and oral tradition. The most celebrated of these early Pueblo artists were Fred Kabotie, Otis Polelonema, Awa Tsireh, Encarnacion Pena, Julian Martinez, and Velino Herrera.

In the Santa Fe of the 1920s, where an art community was coming to life among white settlers and dilettantes such as Mabel Dodge Luhan, the public became progressively interested in Indian art. But the repression of the Native painters did not change officially until 1933, when John Collier became Commissioner of Indian Affairs. The next year the Indian Reorganization Act finally lifted the ban on teaching Indians about their arts and heritage. This political change was of great help to Dorothy Dunn, a white art historian from Chicago who had recently founded a studio at the Santa Fe Indian School—one dedicated to the revolutionary purpose of encouraging rather than obliterating the particular artistic expression of Indian peoples. The Studio eventually became a major center of art education for Indians—so much so, in fact, that its illustrious history has tended to eclipse the creative activities of Indians in other areas of the United States and Canada.

Meanwhile, the revival of Plains Indian art had begun about 1928, when Mrs. Susie Peters, a field-worker on the Kiowa Reservation near Anadarko, Oklahoma, became enthusiastic about the drawings of a group of talented boys. Their work was called to the attention of Oscar Jacobson of the School of Art at the University of Oklahoma, and they were eventually accepted there as special students, becoming the first Indian painters officially to receive some kind of formal training in an Anglo institution. They were known variously as the Kiowa Five or the Five Kiowa Boys—though in reality there were more than five of them, and at one period a girl named Lois Smoky was included in their circle.

At about the same time, the Studio at the Santa Fe Indian School opened classes for promising artists from tribes throughout the United States. From 1932 to 1937, under the direction of Dorothy Dunn, the Studio helped bring into focus a style of Indian painting that, together with the works of the Kiowa Five and the Ledger Art of the imprisoned Plains Indians of Fort Marion, epitomizes what is called Traditional Indian painting.

After World War II, Traditional Indian painting became increasingly homogenized, and most of its regional and tribal elements began to disappear. As is often the case among tribal peoples whose art cannot be supported by their own economy, a "tourist mentality" began to intrude upon the sensibility and taste of

Indian artists. A few of them produced the mediocre work favored by some American tourists above the subtlety and excellence of Traditional Indian art at its best. Despite the faltering of the Traditional style, however, a number of artists retained the standards of the idiom. Jerome Tiger, Blackbear Bosin, Rance Hood, Rafael Medina, and Raymond Naha produced works that were largely influenced by the elder Traditional masters, except for a new emphasis on motion and painted backgrounds, an emphasis that probably arose from the impact of a Navajo painter named Quincy Tahoma who had studied at the Studio, where he evolved a style so filled with violent movement that it verges on Expressionism.

By and large, however, the great day of Traditional Indian art was ending. Something new was on the horizon. By the end of World War II, the Indian perspective had changed considerably. Service in the U.S. Armed Forces had introduced young Indians to the startling breadth and diversity of world cultures. The acceleration of communications had brought alien images into reservation living rooms. And the educational facilities available for the first time to Indians—through tribal schools and universities that became accessible under veterans' programs—were reshaping the Native American perspective. The real breakthrough occurred in 1962 when a conference funded by the Rockefeller Foundation was set up at the University of Arizona with the purpose of exploring the future of American Indian art.

Ten to twenty years earlier, however, the inevitability of something called Contemporary Indian art had already become a reality in the works of at least two major artists. One of them was a Yanktonai Sioux named Oscar Howe who had studied at the Studio in Santa Fe under Dorothy Dunn. While there and for several years after leaving, he dealt with Traditional subjects in the nostalgic manner of the Studio, occasionally basing his art on nineteenth-century Plains hide paintings. Then, during World War II, he spent nearly four years in Europe with the U.S. Armed Forces, where his exposure to European art had a profound impact on his viewpoint. He returned home to attend the University of Oklahoma, where he gradually began to evolve a style of painting that was highly improbable—it had never before appeared in the work of an Indian artist—a special kind of neo-cubism. By doing this, Howe unmistakably bridged the gap between Indian art and mainstream art.

There was another important painter with whom Howe shared his position in the avant-garde of American Indian artists. His name was Joe H. Herrera and he came from Cochiti Pueblo, the son of the pioneer Pueblo artist Tonita Pena. Herrera joined Dorothy Dunn's program at the Studio in the fifth year (1936) and began almost at once to evolve a radical style. "His work," Dorothy Dunn has said, "was unlike that of his renowned mother, for his was coolly

Oscar Howe: *"Origin of Corn," 1946; courtesy of the University of South Dakota, Vermillion.*

decorative where hers was warmly natural." Herrera's mode of painting continued to change as he entered the University of New Mexico to study under Raymond Jonson, a non-Indian teacher and painter with a strong cubist inclination. As a result of his own evolution and the influences of the university, Herrera won renown for his highly personal style when he held an exciting one-man show at the Museum of New Mexico in 1952. This style was an abstract presentation of antique symbols, taken largely from rock paintings and ceremonial *(kiva)* murals of the Southwest.

Herrera eventually received an invitation to exhibit at the Museum of Modern Art in New York, which made him one of the first Indian painters to gain recognition for successfully changing from the Traditional style to a unique idiom influenced by mainstream Anglo art. He abandoned the deliberate traditionalism of Pueblo art as it was understood at the Studio and gave himself, with Jonson's influence, to the visual theories of Kandinsky, Klee, and the analytic cubists. The result was an Indian art with strong accents of cubism and art deco. Herrera's methods, using casein tempera in a natural-toned palette and a combination of spray and brush application, were totally unfamiliar to Indian art. Several other Indians have subsequently experimented in the same style, including Pablita Velarde, Helen Hardin, and Tony Da.

By 1960, when the Indian Art Project conferences at the University of Arizona examined the future of American Indian art, the stage was well prepared for a drastic new direction in Indian artistic expression. The result, in 1962, was the founding of the

Joe H. Herrera: *"Eagles and Rabbit,"* *1952; courtesy Philbrook Art Center, Tulsa.*

Institute of American Indian Arts (IAIA) in the same buildings in Santa Fe where Dorothy Dunn's Studio had ushered in a grand era of Traditional Indian painting.

It is an error, however, to believe that *all* Indian painting and sculpture of the recent past is devoted to the Contemporary idiom and that *all* Indian painters of value were trained by the Institute of American Indian Arts in Santa Fe, for Indian art is highly divergent and has evolved in a great many different regions of North America. But there is simply no question that the Institute has turned out most of the important young Indian painters during the 1960s and 1970s.

The Institute of American Indian Arts was created by the Indian Arts and Crafts Board of the U.S. Department of the Interior and by the Bureau of Indian Affairs (BIA). Its intentions were quite different from Dorothy Dunn's purposes of reviving ancient native imagery and style. The new art center in Santa Fe examined Traditional Indian painting and Indian sculpture in the light of twentieth-century art modes. In theory, as a result of that study, the students of painting and sculpture at the IAIA are given both Traditional and Contemporary instruction, but the fact is that the temperament of both faculty and students is inclined to the new wave of individualistic Indian art. Lloyd Kiva New (Cherokee), the director of the IAIA from 1967 to 1979, has stated, for example, "I believe that young Indians should be trained to the point where they

will be able to make up their minds as adults of the future how they will want to present their culture to the outside world."

Jeanne Snodgrass, a leading biographical researcher on Indian painters who was Indian arts curator from 1956 to 1969 at the Philbrook Art Center in Tulsa, Oklahoma, has described the gradual process by which Indian Contemporary modes became visible to the public:

"A decline in productivity accompanied World War II, and it was not until 1946 that Indian art emerged from its slump. It was in that year that Philbrook Art Center inaugurated an annual, competitive, nation-wide exhibit for Indian painters. Similar exhibits were soon instituted by other museums. Scottsdale [Arizona] became a lucrative annual exhibition center, and recently the fine Heye Foundation [now the Museum of the American Indian, New York] under Frederick J. Dockstader started to present one-man shows by Indian artists. In 1959, three years prior to the opening of the Institute of American Indian Arts, Philbrook Art Center presented paintings generally considered to be taking a *new direction*. Thus, Philbrook provided the first major endorsement of the evolution in Indian art and acknowledged the ever-increasing desire of artists to experiment—not to break from their culture, but to explore it and improvise upon it—to effect an integration with the demands of the present. Even the purist, if . . . honest and knowledgeable, must admit that from the very beginnings of Indian art, there have been many styles, many techniques, and many approaches."

The importance of such Indian art centers as Santa Fe, Scottsdale, and Tulsa cannot be underestimated, but at the same time it needs to be pointed out that the exhibitions and art circles of such centers gradually tended to become a bit elitist and self-serving. As we shall see, many new trends from other regions of North America were neglected—partly because the Southwestern status quo failed to recognize them but also, it must be stressed, because artists from Canada, the southeastern part of America, the Northwest Coast, and the Iroquois region of the Northeast were not trained, as IAIA alumni were, in marketing and career management, and they were therefore rather unmotivated professionally and disinclined personally to try to make an impact on the ongoing Indian art scene. There still remains among many traditionalists (and among many non-Indian people, for that matter) a serious question as to whether ambition is a virtue or a fault. Ambition was long considered to be part of the process by which Indians became assimilated and lost their native identities. It is only recently that higher education, personal motivation, and access to Anglo expertise have been seen as a possible means of strengthening, rather than weakening, the Native American heritage. By no means has the moral debate concerning the abundance or the lack of so-called "Anglo initiative" among Indians been settled. Likewise, the battle between Traditional and

Contemporary artists continues, and each year the annual exhibits are tossed by controversy over the reactionary or radical viewpoints of juries. The pressure of contrary aesthetic purposes and the emergence of highly trained Indians have brought about a number of important "storm centers."

One of these, unquestionably, is the Mission Indian painter Fritz Scholder, who has become a symbol to so many young artists of simultaneous aesthetic validity and mainstream success that some Contemporary and most Traditional artists see Scholder as the consummate IAIA mutant. Whenever someone wishes to scorn the "grotesqueness" of modern art generally and Contemporary Indian art specifically, or condemn the twentieth-century relevance of the Institute of American Indian Arts, or point up somebody who is far too sophisticated to be *really* Indian, Fritz Scholder becomes their easy target. By and large his major sin appears to be his success. He is one of the few Indian painters with a major reputation in the leading art cities. Scholder has *visibly* succeeded in combining the influences of European expressionism, specifically the style of the English artist Francis Bacon, and some ingredients of Pop art, into a personal and political attitude about Indians that is entirely legible to both whites and Indians who are experienced in nonillusionist twentieth-century art.

Fritz Scholder was not the only IAIA alumnus (and teacher) to bring about the triumph of Contemporary Indian art. There were two other notable innovators, though they, curiously enough, have received more praise and less criticism than Scholder. T. C. Cannon (Caddo/Kiowa) was deeply mourned in May of 1978 when an

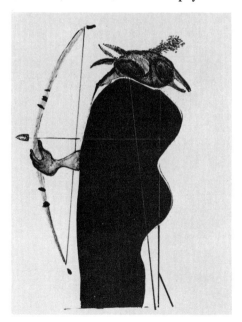

Fritz Scholder: *"Crow Indian Hunter," 1965; courtesy of the artist and Aberbach Fine Art, New York.*

automobile accident brought his life to an end at the age of thirty-two. He was one of the most gifted young painters trained at the IAIA and was clearly a seminal force in the emergence of the Contemporary style, though his works were fewer and less well

known than those of his colleague at the Institute, Fritz Scholder. Another extremely important, pivotal alumnus of the Indian art training center at Santa Fe was the previously mentioned Yanktonai Sioux artist Oscar Howe. He, however, was a student in the days of the Studio of Dorothy Dunn, which long pre-dated the controversial modernism of the IAIA. Yet Howe clearly bridged the gap between Indian art and mainstream modern art. He was also one of Scholder's early teachers. Why, then, didn't Howe cause the kind of controversy that has always surrounded Fritz Scholder?

There is no question that Howe was every bit as influenced by experimental European painting as Scholder was. Howe, however, sees a relationship between his personal vision as an Indian painter and the concept of nature as it is understood by European cubists. He therefore expresses his view of reality in the formal reconstruction of the same romantic world that is visible in

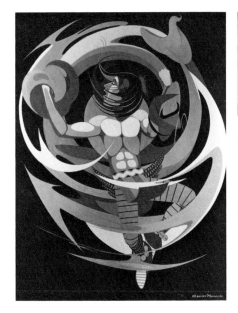 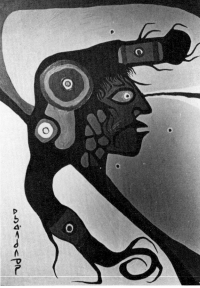

Oscar Howe: *"The War Dancer,"* 1971; courtesy of the University of South Dakota, Vermillion (left); Norval Morrisseau: *"Spiritual Self,"* 1977; courtesy of H. Band collection, Toronto (right).

Traditional Indian painting, though he is essentially using modernist modes to achieve this romantic result. This view of Indians, though structurally revolutionary for Indian painting, hasn't disturbed the most avid Traditional painters, who seem to approve of Howe though he has truly brought off a radical departure from "art" as they know and approve of it.

What has been said of Howe's modernism can be applied to several other less known, but highly significant, artists who are not part of the Santa Fe–Tulsa–Scottsdale scene but come instead from other regional art movements that are only now becoming known to enthusiasts of Indian art. Oren Lyons (Onondaga) resembles Howe insofar as his modernism is essentially romantic and is centered on the familiar heroic and mystical view of Native Americans. The great Canadian artist Norval Morrisseau (Ojibwa) evolved another form of romantic modernism in the early 1960s. This new style, sometimes called Algonquin Legend Painting or Woodland Indian

art, had a vast influence first in Northern Ontario and then in the idiom of an entire "school" of Canadian Indian painters. Equally contemporary in manner and viewpoint is the romantic sculpture of the Eastern Cherokee John J. Wilnoty, whose little-known carvings have had a deep impact on young Indian artists of North Carolina since the mid-1960s. Thus it becomes clear that the Contemporary styles of Fritz Scholder and other alumni of the Institute of American Indian Arts represent very prominent and far-ranging, but nonetheless partial, aspects of the experimental forces at work in Indian art of the late twentieth century. The evolution of the isolated but locally influential and distinctive idioms of recent Canadian Indian art is a good example of artistic activity far outside the direct impact of the well-promoted United States art scenes.

The modernism of these mid-twentieth-century Indian artists is unique and unprecedented in tribal life. In the Indian world the pervasiveness of *change* as it is understood in the West does not exist. No Einsteins, Freuds, Darwins, or Picassos are to be found in the Indian world. Change exists among Indians, but it is change unconnected with the idea of "progressive" evolution. The invention of agriculture in pre-Columbian America, the later reintroduction of the horse to the Western Hemisphere—these were forces that brought great, widespread changes in the lives of Indians, but these changes did not arise from internal, individualized convictions that challenge the cultural status quo. Such rebelliousness is unheard of among tribal peoples, who have an exquisite homogeneity that puts them directly in touch with their culture and with its carefully prescribed and perpetuated forms.

In all spheres of Indian life, harmony with the tribe is mandatory. Even culturally, the highly individuated Western concept of "the artist," and the artist's idiosyncratic efforts to achieve expressive originality, is virtually unknown among traditional, pre-1960s Indians and other aboriginal craftsmen, whose work is considered to be no more rarefied than the work of the farmer, the hunter, or any other person. But this communal conformity is not limited just to primal people. Even in the West, both rebelliousness and intellectual and artistic inventiveness are relatively new and radical precepts. Europeans of the time of Columbus had a very dim view of heretics and have only recently learned to live with, and even to profit from, their "creative anarchy." The Romantic Age, with its emphasis on personal experiences, feelings, and visions, greatly implemented the recognition of a professional person such as "the artist." Today we take it for granted that Western people have always celebrated such superstars as Salvador Dali and Pablo Picasso, but, as art historian Herbert Read has shown in *Icon and Idea*, "the self" in art and in daily life is an invention of fairly recent vintage. It is also an invention that need not follow a single line of development.

"Even when in later historical times [Read wrote], the artist was differentiated from other craftsmen, and his skill was developed as an individual talent, even then there was the strongest impulse to achieve an ideal uniformity, and although distinct personalities do emerge among the sculptors, for instance, of classical Greece, it is very difficult to ascribe any personal accents to the work of a Myron or a Praxiteles—they did not express, and were not expected to express, the uniqueness of an individuality."

Only gradually did the West invent its special (but in no way universal) concept of the individual.

Among primal peoples who have not fully subscribed to the Western notion of progress, such a betrayal of the self is so remote from daily life that originality and assertiveness are generally looked on as faults.

In the 1920s, the Zia Indian painter Velino Herrera provided drawings of the sun symbol of his tribe to white officials, who adapted it as the logo of the State of New Mexico. Herrera's behavior was considered so outrageously individualistic, even for Pueblo Indians of the early twentieth century, that he was cast out by his people, his property was confiscated, and he never again won acceptance by his tribe. His "error" was not simply a matter of giving away secrets to the white man; his fundamental offense was the fact that he acted out a personal conviction. His action betrayed whatever it is within us that we call *ourselves.*

It is heresy among primal peoples such as Indians for someone to depart from communal mentality. It is also heresy among some Indians for a Native American to attain sophistication. One thing conservative Indians and non-Indians seem to agree about is that "good" Indians are supposed to remain pure, which means static. So intense is this attitude toward Indian purity that a sophisticated and articulate Indian is not considered to be *really* Indian. In fact, the Indian regard for conformity is so intense that psychologists working with urbanized Native people have often pointed up the fact that their individuated patients suffer the same sort of intense guilt *toward their tribes* that rebellious whites suffer in relationship *to their parents.*

Indians as individuals, however, are discovering "change" in their own way and in their own time. They are also discovering "themselves" for the first time. Many Indians believe that this evolution of an Indian concept of the individual is intrinsic to Indian mentality. Though urbanization and the influence of idiosyncratic Western behavior have undoubtedly promoted the growth of individuality among Indians, it is also possible that the singularity and personal charisma sought by most Plains, Northeast, and Southeast Indians (in their vision quests, their triumphs in hunting and warring, and so forth) would have been the basis for an eventual evolution toward individuation. In other words, it is possible that

Indians might be equally and uniquely individualistic today even if they had persisted on this continent without the influence of Westerners. We shall never know.

Considering all these possibilities, it is not surprising that within the last decade several "schools" of idiosyncratic art have grown out of the daring and contrariness of artists who have sidestepped or openly defied tribal taboos and tribal expectations. Such a school of art is the so-called Canadian Algonquin Legend Painters that has taken shape recently in Northern Ontario.

One of the most interesting and innovative forms of North American Indian painting is the result of this movement among the Woodland Cree and Ojibwa peoples in the northern regions of Manitoba and Ontario, Canada. The principal focus of this important new school of Indian art is the oral tradition of a group of Algonquin-speaking people (Ojibwa-Odawa-Cree) who are together known as Anishinabek. Their art is devoted to the visual realization of legends and tales of their wide region, which stretches from the north shores of the Great Lakes to the Barren Lands of the Arctic.

Rock art, like Ojibwa Midewiwin Society symbolic scroll "writing," is a pre-Columbian mixture of imagery and mnemonic signs. Courtesy of the Utah Travel Council.

The antecedents of this new art are discovered in the granite landscape of the Precambrian shield area, where ancient rock paintings have survived hundreds of winters. The same figurative motifs and mnemonic symbols may also be found among the bark scrolls of the Ojibwa Midewiwin society, which were central elements in the ritual life of this society devoted to the treatment of illness and infection.

It was the Ojibwa Indian Norval Morrisseau who brought this ancient pictorial heritage vividly into the twentieth century when he began in 1959 to recapitulate aspects of the iconography of his ancestors in contemporary paintings. Born in 1933 on the Sand Point Reserve on Lake Nipigon, Ontario, Morrisseau was the first of his people to break the Algonquin taboos against the pictorial representation of the legends in forms that might be seen by non-Indians. Today, Morrisseau is one of Canada's major Native American artists, and his influence has been very wide among other

Ojibwa and Cree painters. Of those who have most successfully evolved personal idioms out of Morrisseau's striking and original style are the Cree artist Carl Ray (who was killed in a brawl in 1979), the Odawa Indian Daphne Odjig, the Ojibwa Samuel Ash, the Cree-Saulteaux Indian Jackson Beardy, and the Cree brothers Goyce and Joshim Kakegamic. Though these Canadian Indian artists are far removed from the cosmos of Santa Fe, Tulsa, and Scottsdale, they have produced equally impressive work.

But originality is not much admired in Indian art. The West is in such a state of social upheaval that it wants to spare "Indian innocents" the pain of progress; it wants Indians like Norval Morrisseau to stick with available stereotypes that envision Indians as the last natural people and the mighty purveyors of a static, unyielding traditionalism. But, clearly, being Traditional and being reactionary are not the same things, and Indians are evolving into the future just as all peoples must, slowly or abruptly. It is difficult to think of an Indian artist who better represents this recent and total rebelliousness than Norval Morrisseau. He is truly the Indian Gauguin—not simply because both he and Gauguin were renegades and rebels but because Morrisseau's rebellion is uniquely Indian, born out of his personal rejection of the constraints of the Indian world in which he grew up which seemed to forbid him the convictions of his own mystic and personal revelations. Both Gauguin and Morrisseau walked out on their very different but equally formal worlds—one seeking far-flung, exotic islands while the other sought a deep familiarity with Canada itself. One searched externally, while the other retreated within his own undiscovered natural world. And both produced a kind of art that angered and perplexed their very different audiences. Yet neither of them apologized for doing what they did or attempted to mend the rift with society caused by their singular sort of behavior. Each was renowned for his peculiarities. Each was absolutely atypical of the culture that produced him. Morrisseau can be seen as "eccentric" from the viewpoint of Westerners because he went off into the forest to live with nature; but much more importantly, from the standpoint of this discussion, his *real* eccentricity from the Indian viewpoint is the fact that he thinks for himself, wants to be by himself, and has broken taboos against the will of his tribe. Gauguin's individuality was a process long-coming in the white world. Morrisseau's rebellion is uniquely Indian, and it has been emerging among Native people for perhaps two generations.

Throughout all this depiction of Indian individualists as rebels, let us recall that none of them are repudiating the validity of the Indian world or attempting to escape from it into some other world. To the contrary, as their statements often declare, they are highly traditional people and their works focus on vital aspects of Indian culture. They often consider the inspiration for their art to be

visions, revelations, and personal power. The difference between these Contemporary artists and Indian craftsmen of the past is that people like Morrisseau, Scholder, Cannon, and Morrison insist on presenting whatever they personally envision as "reality"—and they do so with or without tribal consent because the very core of their unprecedented motivation is to assert *themselves as Indian individuals* in highly personal and idiosyncratic images.

For the first time Native people in North America are producing intellectuals, artists, and militants who selectively profit from, and effectively cope with, the Western world. Indians are creating new definitions of what it means to be Indian in the twentieth century and beyond. In Contemporary American Indian art we clearly see the American Indian re-created as an Indian individual.

Unlike much recent Indian art, Indian sculpture in the Americas is not a new art form, for it has a long and vital history. The carvings of the Haida, Tlingit, and many other tribes in wood, bone, ivory, and slate are exceptional for their ceremonial significance and artistic achievements.

Haida slate carving from British Columbia, courtesy of the Museum of the American Indian, Heye Foundation, New York (left); Mortuary sculpture of the Hopewell culture, ca. 300 B.C.; courtesy of the Museum of the American Indian, Heye Foundation, New York (right).

Human effigies from the ancient Southeastern United States were unequaled for their massiveness and realistic detail, and in the same region beautifully polished bird effigy bowls and plates engraved with sacred symbols were brilliantly carved from the hardest stone. The catlinite elbow pipes of the Northern Plains were stone carvings of the first rank; while the great effigy pipes of Spiro Mound in Oklahoma and the Hopewell mounds of the Ohio Valley (ca. A.D. 300) reveal superb craftsmanship in the depiction of delicate and naturalistic animal forms.

In the far north, Eskimo artists possessed a genius for realistic carving in ivory and bone. Large-scale sculpture dominated the

Pacific Northwest, where ritual carvings represent the peak of Traditional Native American wood carving. These totem poles and great house posts depict legendary characters and ancestral figures, carved from the immense timber of the region and often vividly painted.

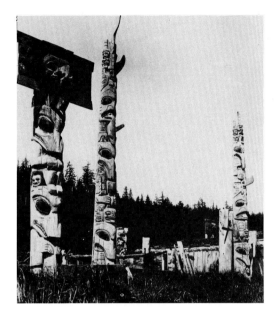

Monumental Haida Indian sculptural poles in Skidegate Village, Queen Charlotte Island, British Columbia; courtesy of the Museum of the American Indian, Heye Foundation, New York.

Equally impressive are the carved and painted masks and box drums of the Northwest Coast, where tribal art has had a vigorous recent revival during the 1970s, preoccupying most of the young artists of the region with Traditional styles in lieu, at least for now, of experimentation in Contemporary idioms. In the Southwestern United States, sculpture has had a long history among the various Pueblo people, whose small animal fetishes of stone and wooden kachina figures attained a sublime perfection of ritual expression and technical finesse.

Native sculpture of the twentieth century did not gain central or serious consideration until very recently. It was the work of the Blackfeet artist Hart Merriam Schultz (1882–1970) that made the first widespread critical impact in America. Working under his Native name, Lone Wolf, he was one of the first contemporary Indian artists to produce sculptures. Born on Birch Creek near Browning, Montana, Lone Wolf was a skilled Traditional painter, but it was in his sculpting that he achieved a new artistic focus for Indians. During the 1920s and 1930s he turned his attention from painting to sculpting and produced highly realistic works of intricate decorative detail and tumultuous action. As Patricia Janis Broder has pointed out, "His works follow more in the artistic traditions of the white man than of the Indian, and are close in style and subject matter to the creations of his fellow Montanan, Charles Russell."

Another early Indian sculptor was Roland N. Whitehorse, a Kiowa Indian born in Carnegie, Oklahoma, in 1920 who produced

bronzes and sculptures that are closely related to the Traditional style of Indian painting.

It was not until the famous Cherokee wood sculptor Willard Stone began to produce his award-winning works in Oklahoma in the late 1930s that Indian sculpture attracted substantial public attention. He was trained by Acee Blue Eagle and Woody Crumbo at the famous Bacone Indian College in Muskogee, Oklahoma, during the height of that school's program in the 1940s for Indian artists of the Southern Plains.

The impact of Willard Stone's work on Oklahoma Indian artists has been considerable, but undoubtedly his most significant influence occurred many miles away from Oklahoma among the Eastern Cherokee artists of North Carolina. Amanda Crowe is the most important contemporary carver in the Willard Stone tradition. Trained at the Chicago Art Institute and for many subsequent years a teacher of wood carving in the Cherokee Indian School in North Carolina, Crowe is perhaps best known for her small-scale Traditional animal carvings.

Two other important Eastern Cherokee sculptors are Going Back Chiltoskey, whose wood carvings are charming depictions of daily life among his people, and John J. Wilnoty, who has produced Traditional carvings in wood and, more recently, a succession of startling and original stone carvings.

Another interesting sculptural achievement was made by the short-lived Creek-Seminole Indian artist Jerome Tiger (1941–67).

Born in Tahlequah, Oklahoma, Tiger produced a highly original and profoundly romantic variation on the Traditional style of painting. Toward the end of his life, Tiger began working in clay. His most important effort was achieved just prior to the accidental shooting that resulted in his death. It is a work entitled "The Stickball Player."

Another early Indian sculptor was John L. Clarke (1881–1971), who was highly regarded as a wood-carver. A Blackfeet Indian born in the Sweet Grass Hills of Montana, Clarke is best known for his sculptures of animals.

Also born in Montana of Blackfeet parents (in 1938) is Gary Schildt, who has produced naturalistic sculptures that are highly influenced by Western art, especially that of Charles Russell.

Of an entirely different artistic temperament is the Choctaw Indian artist Saint Clair Homer II or Homma, who was born and raised in Oklahoma. Patricia Janis Broder has commented perceptively that his sculpture "has evolved from narratives of the West to poetic creations which express the dreams and desires of the Indian."

Of all these interesting and excellent sculptors, none has made the cumulative impact of a Chiricahua Apache from Oklahoma named Allan Houser (Haozous). Through the creation of a succession

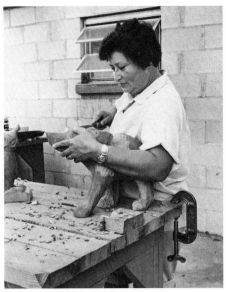
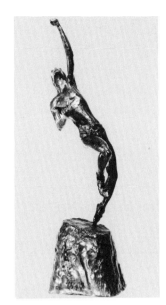

(left to right) Willard Stone: *"O, Great Spirit," ca. 1960; courtesy of the artist; Amanda Crowe at work; courtesy of the Cherokee Historical Association, North Carolina;* Jerome Tiger: *"Stickball Player"; bronze; courtesy of Native American Painting Reference Library, Oklahoma City.*

of marvelous innovative pieces he produced in Santa Fe in the 1960s and 1970s, Houser has almost single-handedly inaugurated the Contemporary style of Indian sculpture. In 1924 he had been a student of Dorothy Dunn at the Studio. He made his first impact as a painter in the Traditional style and only later became attracted to sculpture. His carved pieces, though not conspicuously modern in intent, evolved a spatial character which had such a strong and pervasive influence on younger artists that it is safe to call Houser the precursor of American Indian Contemporary sculpture. His influence was much facilitated by the fact that he has been on the faculty of the Institute of American Indian Arts in Santa Fe for several years.

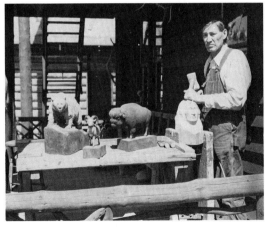
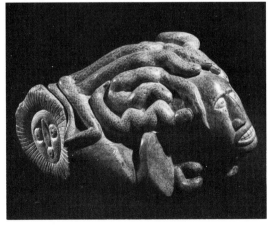

John L. Clarke, *ca. 1945, in Montana; courtesy of the Arts and Crafts Board, Bureau of Indian Affairs, Washington, D.C. (left);* Duffy Wilson: *"To-Do-Da-Ho," ca. 1973; courtesy of the Heard Museum, Phoenix (right).*

Another seminal figure in Contemporary Indian sculpture is the Tuscarora artist Duffy Wilson, who in 1969 introduced carvings in a material called steatite. Brown steatite is found in North Carolina, the region from which Wilson's tribe was removed and relocated in Upper New York State at the beginning of the eighteenth century and where the Tuscarora people eventually became members of the Iroquois Federation. Originally a house painter, Wilson exhibited an unusual gift as a sculptor, and in 1973 he won the Heard Museum (Arizona) Prize for Indian Art for his sculpture entitled "To-do-da-Ho." This startling piece depicts a crouching, naked male with one of his legs raised and the other folded under his body, his head wreathed with serpents. This and many of the other sculptures by Duffy Wilson have a curious and unexplainable visual relationship to the stone carvings of John J. Wilnoty of North Carolina, and both these talented artists appear to have been motivated by an influence from the low relief stuccos and sculptures of the Aztec and Maya cultures of Mesoamerica. Considering the often-observed influences of ancient Mexican art on the effigies and mortuary sculpture of the Mound Builders of the Mississippi and Southeastern regions of America, it is possible that in the works of these two Indian sculptors we see the re-emergence of a very ancient North Carolina style of stone carving. Thus the cycle is complete: New springs come out of old winters, and the innovative impulse of Native American art, like that of twentieth-century Anglo art, might be seen as a renewal of primal images in materials and with techniques unique to our time.

This book is an effort to make visible some of those marvelous achievements of Contemporary North American Indian artists. Not all the excellent Native Americans working in the arts today are included; the Contemporary schools of Indian art are still too formative and transitional to permit a definitive history of their achievements or a presentation of all their important leaders. But the latitude and the diversity of living Indian artists are so startling, beautiful, and expressive that even a limited spectrum of their works will surely provide us with intense aesthetic enlightenment and enjoyment. This tribute to some of the great Contemporary artists will also serve as an inspiration for the many young Indians who are now art students, requiring vital role models forged not from the vantage of Anglo art but from their own Indian artistic cosmos.

Today, whenever Indian artists concern themselves with that cosmos, whether in figurative or nonobjective art, a unique point of view and elements of a highly individual style emerge from the combination of a tribal sense of heritage and a twentieth-century grasp of art techniques. It is an ancient story that continually renews itself. It has been a source of Indian nationalism and pride since 1875, when the last hope of survival for Indians was deeply shaken.

Marvin Oliver: *"Bear, 1977; carved in fir; courtesy of the Daybreak Star Indian Center, Seattle, and the artist.*

In those days the desperation was countered by the spread of a frantic ceremonial philosophy called the Ghost Dance, which sprang from the vision of a prophet who promised that the dead would live again. The faith in this revivalist religion was epidemic among Indians, and it ended in tragedy. A band of Ghost Dancers in their painted shirts, which they hoped would magically protect them from bullets, were among the victims of the slaughter at Wounded Knee in 1890.

Now the dancers in their shirts painted with marvelous icons are gone, but the dance goes on . . . in the paintings and sculptures of Indian artists in whom vision is irrepressible, in whom the warriors, the holy people, the buffalo, and the sweet grass live on. In great art everything is possible—even the vision of a future in which Indians still dance and sing in a great expanse of unspoiled land newly named America. It is that undying world which is made visible by the exceptional artists whose works fill these pages.

THE ARTISTS

The Aleut artist Alvin Eli Amason was born in 1948 in Alaska. After
attending high school in Kodiak, he received his B.A. and M.A.
degrees from Central Washington State College in Ellensburg and
his M.F.A. degree in 1976 from Arizona State University in Tempe.
He now lives in Anchorage with his wife, Katharine. They have two
sons, William and James.

Amason is an active art organizer, teacher, and lecturer. He has
taught or lectured at colleges in Washington and at the Navajo
Community College in Chinle, Arizona, the Institute of American
Indian Arts in Santa Fe, and the University of Alaska in Juneau. His
work is in several major collections: the National Gallery of Fine
Arts in Washington, D.C., the Alaska State Museum in Juneau, the
University of Alaska Museum, and the Baranof Museum in Kodiak.

Two recent major commissions, both in Anchorage, Alaska,
were from the Calista Native Corporation (1978) and (1979) for the
United States Federal Courthouse Building (with fellow artists Sam
Francis, Dan Flavan, and Robert Hudson).

"Papa was a bear guide, trapper, and spoke good Aleut. We lost
him two winters ago. We still take Grandma out to gather beach

grass for baskets and to dig clams on the Island. Billy is a good fisherman now, and Jimmy is lead guitar somewhere in Canada. Kathy is going back to college. And I still am painting. I love these visual journeys and smoked salmon. You gave me my vision, Papa."

Alvin Eli Amason: *"Papa never saw a walrus neither,"* 1979; oil, wood, plastic; 60 × 84 in.; courtesy of National Gallery of Fine Arts, Washington, D.C.

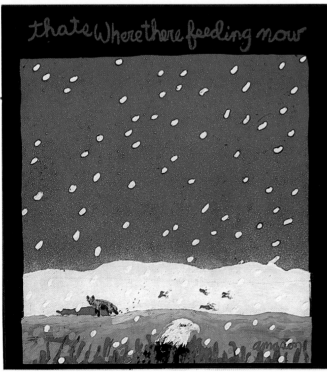

Alvin Eli Amason: *"Feeding Place,"* 1977; oil/acrylics on canvas; 48 × 50 in.; courtesy of the artist.

ROBERT ANNESLEY

The Cherokee Indian artist Robert Annesley was born in 1943 in Oklahoma. He attended the University of Oklahoma and Oklahoma City University (1961–66), majoring in Fine Arts. After 1967 he devoted his full energies to his career and has had retrospectives of his work at the Cherokee National Museum in 1976 and at the Southern Plains Indian Museum in 1977.

Annesley is highly regarded for his tribal research to assure the authenticity of his work, which depicts the traditions of his people. The encaustic mixed-media technique Annesley utilizes in his paintings is a slow, exacting process involving the use of beeswax interspersed with the paints to set the colors and finally requiring the work to be baked in an oven. Owing to the complex procedure of this technique, Annesley can produce only two or three such works each year. Graphic techniques employed by Annesley are based on very old methods such as the use of a handmade silver stylus and special papers prepared in the manner of the Renaissance masters of the fourteenth through sixteenth centuries. Annesley works in a wide range of media.

Among his exhibitions have been the Philbrook Art Center's Annual American Indian Artists National Exhibition, the Five Civilized Tribes Museum's Annual Exhibition, the Heard Museum

Guild's Indian Arts and Crafts Exhibition, the Annual Scottsdale National Indian Arts Exhibition, the Cherokee National Museum's Annual Exhibit, and the Los Angeles Indian Arts Show. Annesley has also served as a juror for the Philbrook Art Center's 1977 show. He now lives in Houston, Texas, with his wife and their daughter.

Robert Annesley: *"Tso batso—To the Rocks," (two views), 1978; bronze; 12 × 13 × 10 in.; courtesy of the U.S. Department of the Interior, Southern Plains Indian Museum, Anadarko, Okla.; photograph by Ken Drueger.*

"I am an artist . . . I am an Indian. Both of these things influenced my life and the way I perceive the world around me. My work is a combination of subject matter and the abstract considerations of artistic expression. My choice of subject matter is usually my source of inspiration. This is found within history and legends, and the people that I have actually and imaginatively known in my life. Thus, I am also preserving and recording these things for our future generations. However, my primary objective as an artist is the creation of valid art. To achieve this goal I select, delete, and arrange the subject matter according to my own aesthetic interpretation. This reconstruction creates the illusion of reality while giving my art a power and personality of its own. When all these elements are combined with technique, acquired from experience, and the intangible qualities of sincerity and sensitivity, art becomes magic and speaks in a universal language."

Samuel Ash is an Ojibwa Indian painter born in 1951 in Sioux Lookout, Ontario, Canada. He is a deaf-mute whose work has been frequently singled out as the most evolved of the Algonquin Legend Painters, as a contemporary "group" of Ontario painters is known.

Only through the most arduous efforts was Ash able, because of his inability to speak or to hear, to acquire the full folk history and traditions of his people. As John Anson Warner, an expert in the field, has pointed out, "His most notable characteristics are an absolutely sure sense of line along with a phenomenal understanding of color."

Samuel Ash: *"Gone to Heaven,"* 1977; acrylics on paper; 30 × 22 in.; courtesy of Bernhard Cinader Collection, Toronto.

Samuel Ash: *"Moose, Men and Three Beavers,"* 1977; acrylics on paper; 16 × 20 in.; courtesy of John Anson Warner, Regina.

Samuel Ash: *"Six of Sharp Teeth,"* ca. 1976; acrylics on paper; 16 × 20 in.;
courtesy of John Anson Warner, Regina.

Asa Battles was born in Buckeye, Arizona, and spent most of his youth working on ranches there. On completing high school, he was inducted into the army and served in three major campaigns in the Tank Corps in Europe during World War II. After the war he returned to the United States, married, and in 1953 moved to Denver, Colorado, where he now lives. Widowered, Battles remarried in 1969, and with this second marriage came a major turning point in his career in the arts. Of Choctaw heritage, Battles had long studied history, legends, and the religions of Native people, but his Anglo wife gave a new focus to his devotion to Indians. His tribal relations have included the Apache, Maricopa, Navajo, Pima, and Papago. And once he moved to Colorado, his research and fieldwork brought him close to Plains Indian traditions.

Asa Battles is an Honorary Member of the Colville Confederated Tribes and an Honorary Chieftain in the Chief Joseph Band of the Nez Perce. Among his many awards are the Silver Medal from the Second Annual George Phippen Memorial Art Show in Prescott, Arizona, in 1976, a Blue Ribbon for Best in Category and Blue Ribbon for Best in Show at the Bicentennial Century of Western Art in Denver, the Gold Medal from the 1977 Western Trails Art Show, the Bronze Medal at the 1977 Western Heritage Art Show, the First

Award for Graphics at the 1978 American Indian Artists Exhibition of the Philbrook Art Center, and Third Award for Graphics from the Red Cloud American Indian Show in 1978. Among the several books illustrated by Asa Battles are *Medicine Bag* and *Queen of the Wolves* (for Houghton Mifflin Company) and *Fodor's Indian America* and *Ritual of the Wind* (by Jamake Highwater).

Asa Battles; *"Hopi Ladies,"* 1977; scratchboard; 24 × 36 in.; courtesy of the artist.

Asa Battles: *"Silence,"* 1977; scratchboard; 12 × 18 in.; courtesy of the artist.

Jackson Beardy, an Ojibwa Indian, was born in 1944 at Garden Hill Reserve, Island Lake, Manitoba, Canada. At the age of six he was sent to a residential school, but after high school he returned to the reserve to study, paint, and write about the culture, life, and legends of his own people. This became his life-style for three years, until he decided to enroll in the University of Manitoba to study art.

In 1971, Beardy joined the staff of the Museum of Man and Nature as a field researcher, thus gaining valuable new experience and insights into his people in Northern Manitoba and Northeastern Ontario. Eventually this cultural learning was the topic of his lectures at the Fine Arts Department of Brandon University in Manitoba.

Jackson Beardy is closely associated with the movement of Canadian Indian art generally called the Algonquin Legend Painters. The influence of Norval Morrisseau, the "founder" of this school of painting, is visible in Beardy's approach, though his work has strong individuality and original content.

Intricately interwoven in his work are the legends of his Cree-Saulteaux background. Of all the Algonquin artists, Beardy probably displays the greatest skill in drawing and the most sophisticated sense of how a painting should be organized. He now

lives in Winnipeg, Manitoba, where his work enjoys great prominence.

His first exhibition was at the University of Winnipeg in 1965. Since then he has shown at major art galleries across Canada: the Winnipeg Art Gallery, Dominion Gallery, Robertson Gallery, Images Gallery, and many others. Beardy's work has also been seen in Europe, in exhibitions in London, Germany, and Holland. His paintings are in the following public collections: the Canadian McMichael Collection, the Shell Canada Collection, Arts Bank Canada, the National Museum of Man, and the Supreme Court of Canada.

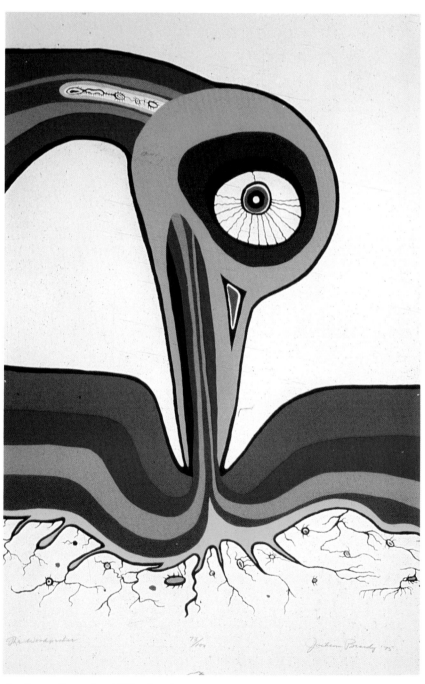

Jackson Beardy: *"Woodpecker,"* 1976; serigraph, edition of 1,100; 22 × 26 in.; courtesy of the artist.

"I think there are two types of Indian artists. The first is totally involved with his Native culture and is personally responsible to that culture. He is merely a tool of his tribe, responsible for producing work of the highest possible caliber. The second group is not responsible to its tribe. These artists are selling their Indianness first. If you're an Indian and an artist you're not necessarily an Indian artist. I belong to the first category. I can't paint anything if I don't have the background and cultural knowledge to make it right. It wouldn't be fair to my people and it wouldn't be fair to the rest of Canada."

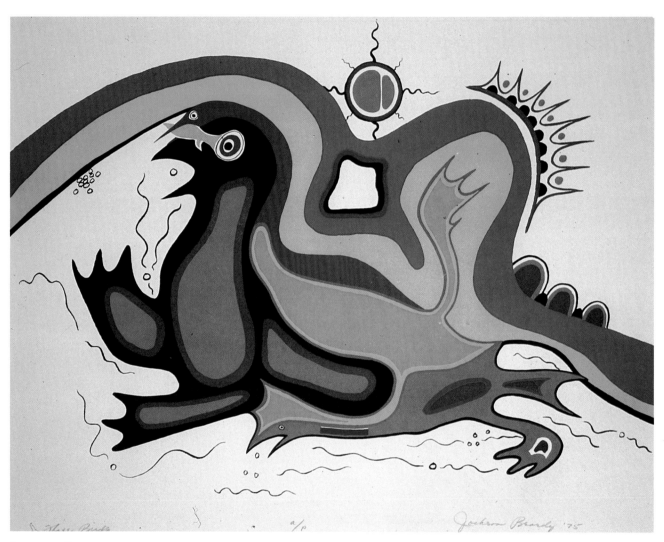

Jackson Beardy: *"Three Birds II,"* 1975; serigraph, edition of 1,100; 22 × 26 in.; courtesy of the artist.

The Apache artist Delmar Boni was born in 1948 in Safford,
Arizona. He attended Fort Thomas High School in Arizona and
received an A.F.A. degree from the Institute of American Indian
Arts in Santa Fe and a bachelor's degree in art education from the
College of Santa Fe. In 1973 he was commissioned to do a painting
for the collection of the American Junior College Board in
Washington, D.C. In 1975 he received the Purchase Award at the
Philbrook Art Center in Tulsa and the Honors Award from the
Institute of American Indian Arts, and in 1977 he won the Martin
Luther King Award. The following year, he became a member of the
Board of Directors for the Southwestern Association of Indian
Affairs, Santa Fe.

Boni's work has been shown at the Scottsdale National Indian
Art Exhibition, the Scottsdale Artist League Show, the Heard
Museum in Phoenix, the Philbrook Indian Art Center, the New
Mexico Biennial Show, the 1977 Santa Fe Armory Show, and in the
1978 Institute of American Indian Arts Alumni Invitational Exhibit.
His work is regularly on exhibition at Los Llanos Gallery in Santa Fe.

In 1976 Delmar Boni founded in Santa Fe the St. Catherine's
Mountain Spirit Dance Group, which he sponsored at St. Catherine's
Indian School until 1978. He presently makes his home on the Gila

River Indian Reservation near Phoenix, Arizona, and is working toward a master's degree in Indian Education.

"I feel that my paintings are influenced mostly by my Apache way of life, and what I've learned in art school."

Delmar Boni: *"Great Native American," 1977; acrylics on canvas; 60 × 48 in.; courtesy of the artist.*

Delmar Boni: *"New Mexico Lady,"* 1978; oil on canvas; private collection.

Delmar Boni: *"Portrait,"* 1974; acrylics on canvas; 72 × 24 in.; courtesy of the artist.

Delmar Boni: *"Great Native American Dream No. 1,"* 1973; acrylics on canvas; courtesy of the artist.

BENNIE BUFFALO

Bennie Buffalo was born of Cheyenne parents in 1948 in Clinton, Oklahoma. He studied at the Institute of American Indian Arts from 1963 to 1967, at the San Francisco Art Institute from 1970 to 1972, and at Southwestern State College in Oklahoma in 1972–73. After spending the early portion of his career in Oklahoma City and Weatherford, Oklahoma, he moved to Santa Fe, New Mexico, where he now lives.

Buffalo's work has passed through three or four distinctive periods, the most recent and accomplished of which is seen in his paintings based on photo-realism.

Bennie Buffalo: *"Portrait,"* 1976; *acrylics on canvas; 48 × 54 in.; courtesy of the Tribal Arts Gallery and Dr. M. A. Shapiro, Oklahoma.*

Bennie Buffalo: *"Sun Dancer,"* 1978; *acrylics on canvas; 72 × 44 in.; courtesy of Los Llanos Gallery, Phoenix.*

T. C. CANNON

T. C. Cannon is a Caddo and Kiowa Indian who was born in 1946 in Lawton, Oklahoma. His Indian name is Pai-doung-u-day, which means "One Who Stands in the Sun." Cannon took two years of postgraduate training at the Institute of American Indian Arts in Santa Fe and also studied painting at the San Francisco Art Institute in 1966. Of the young painters of the new wave, T. C. Cannon was probably the most accomplished. His influence has been widely felt among his own generation as well as successive generations of Indian artists.

T. C. Cannon died in an automobile accident in May 1978.

"I dream of a great breadth of Indian art that ranges through the whole region of our past, present, and future . . . something that doesn't lack the ultimate power that we possess. From the poisons and passions of technology arises a great force with which we must deal as present-day painters. We are not prophets—we are merely potters, painters, and sculptors dealing with and living in the later twentieth century!"

T. C. Cannon: *"As Snow Before a Summer Storm,"* 1972; acrylics on canvas; courtesy of Aberbach Fine Art, New York.

T. C. Cannon: *"Mama & Papa Have the Going Home to Shiprock Blues"; oil on canvas; 84 × 60 in.; courtesy of the Museum of the Institute of American Indian Arts, Santa Fe.*

T. C. Cannon: *"Beef Issue at Fort Sill," 1973; acrylics on canvas; 71 × 55 in.; courtesy of Aberbach Fine Art, New York.*

T. C. Cannon: *"Gamblers," 1974; mixed media on colored paper; courtesy of Aberbach Fine Art, New York.*

T. C. Cannon: *"Indian Dancer,"* 1975; *pen/ink on paper; courtesy of Aberbach Fine Art, New York.*

T. C. Cannon: *"Self Portrait,"* 1976; *pencil on paper; courtesy of Aberbach Fine Art, New York.*

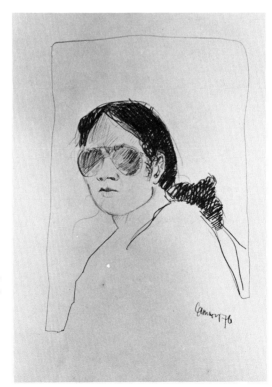

DON CHUNESTUDEY

Don Chunestudey, of Cherokee descent, was born and raised in northern California. His childhood was spent in Benicia, a small town located between San Francisco and Sacramento.

On completing high school in 1966, he attended the Institute of American Indian Arts, where he studied under sculptor Allan Houser. After two years in the army, he returned to California in 1971 to attend college and to focus his energies on his art.

Today Chunestudey works in all media of sculpture, encompassing a wide spectrum of subjects and materials with qualities ranging from realism to abstraction. He also produces surrealistic paintings in oils, acrylics, and watercolors. In 1977 he moved to Santa Fe to accept an apprenticeship with Allan Houser. Chunestudey is currently exhibiting in several galleries in Santa Fe and Tesuque, New Mexico.

Don Chunestudey: *"Desert Ram," 1979; alabaster; 22 × 6 × 10 in.; courtesy of the artist.*

Don Chunestudey: *"Humble Eagle," 1978; marble; 30 × 18 × 4 in.; courtesy of the artist.*

DAWAKEMA (MILLARD LOMAKEMA, SR.)

Dawakema is a Hopi Indian born in 1941 in Shungopovi on the Hopi Indian Reservation in Arizona. Though schooled at the Navajo Mission in Holbrook, Arizona, and other academies, he is entirely self-taught as a painter and had no formal art training. In 1958 Dawakema traveled with a visual education tour, which took him to the eastern seaboard of the United States and Canada. In 1960 when he returned to the Hopi mesas he was initiated into the men's One Horn Society. Dawakema is a member of the Corn-Water Clan, a central group in Hopi religious ceremonies.

After working with a detective agency in Phoenix during the mid-1960s, Dawakema joined the Hopi Police Force in 1968 and has, since then, spent much of his free time painting, taking part in various local art exhibitions, and entering painting competitions. His awards include the 1969 First Place in the Heard Museum's National Indian Art Show, as well as awards won at the Scottsdale National Indian Art Exhibition, the Gallup Inter-Tribal Ceremonial Competition, and the Navajo Tribal Fair.

In 1973 Dawakema joined the group of Hopi artists called the Artists Hopid, and since then he has worked and toured widely with that group. He is the subject of an extended discussion in *Hopi Painting* by Patricia Janis Broder, who provided biographical data and photographs of Dawakema's works for this book.

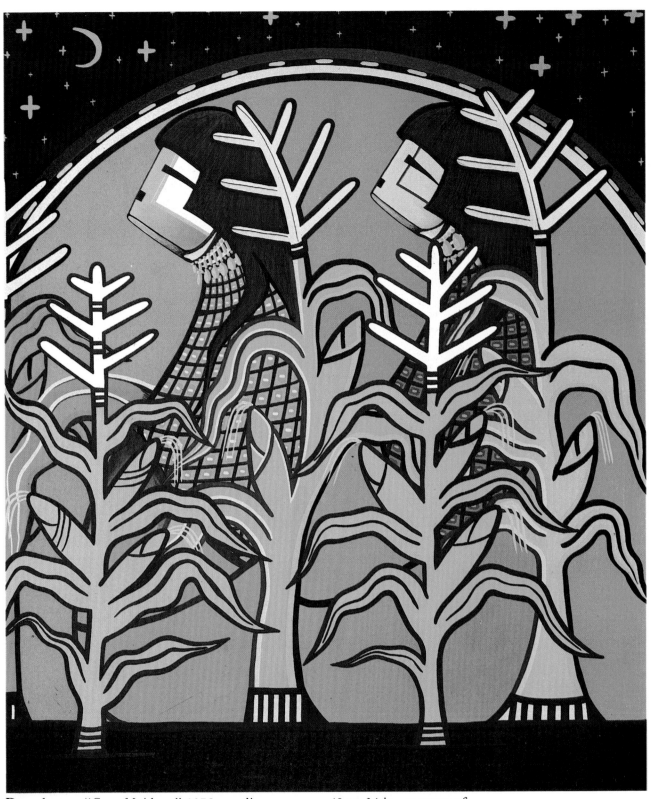

Dawakema: *"Corn Maidens," 1975; acrylics on canvas; 40 × 34 in.; courtesy of the Hopi Arts and Crafts Cooperative Guild, Second Mesa, Arizona; photograph courtesy of Patricia Janis Broder.*

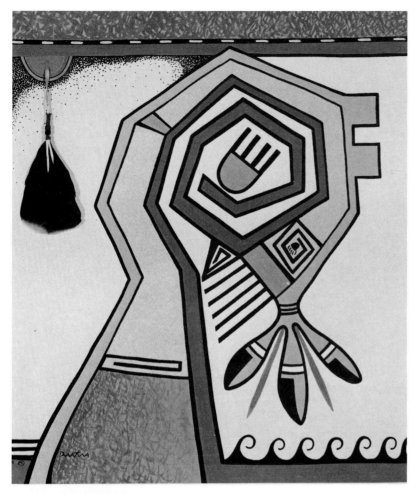

Dawakema: *"Bear and Kachina Migration Patterns,"* *1975; mixed media; 28 × 24 in.; courtesy of the Hopi Arts and Crafts Cooperative Guild, Second Mesa, Arizona; photograph courtesy of Patricia Janis Broder.*

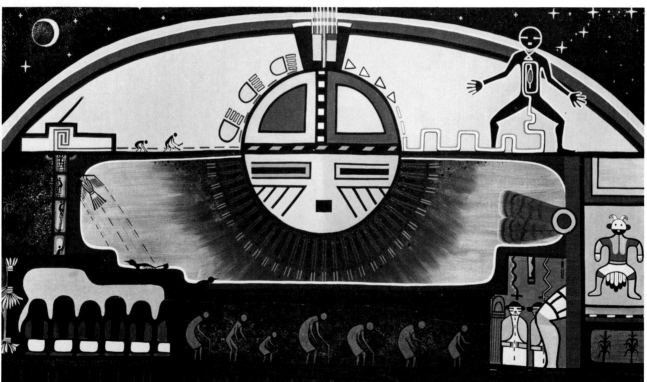

Dawakema: *"Emergence," 1974; acrylics on canvas; 48 × 84 in.; courtesy of the Hopi Cooperative Arts and Crafts Guild, Second Mesa, Arizona; photograph courtesy of Patricia Janis Broder.*

Dawakema: *"Chaguina II,"* 1975; *acrylics on canvas; 20 × 16 in.; courtesy of the Hopi Cooperative Arts and Crafts Guild, Second Mesa, Arizona; photograph courtesy of Patricia Janis Broder.*

Phyllis Fife was born in 1948 in Okfuskee County near Dustin, Oklahoma. A Creek Indian, she attended a rural public school in Oklahoma until transferring to an Indian boarding school in 1963. She attended the Institute of American Indian Arts in Santa Fe from 1963 to 1966 and then studied at the University of California in Santa Barbara, where she trained with muralist Howard Warshaw. From 1970 to 1973 she attended the University of Oklahoma in Norman, where she was awarded her B.F.A. degree.

Fife has taught at Northeastern Oklahoma State University in Tahlequah and Southeastern Oklahoma State University, Durant. Her work has been exhibited in the Heard Museum, the Museum of New Mexico, Oregon State University, the Philbrook Art Center, and the University of Oklahoma Museum.

"The following quotation from an interview with Mark Tobey in Seldon Rodman's book *Conversations with Artists* is very significant to me. 'Tobey is firmly persuaded that the critical moment in a good painting takes place in a kind of trance—a mystical state in which the artist's soul or unconscious guides his hand to solutions undreamed of by the conscious mind.' That just one other person believes this concept makes my work valid to me."

Phyllis Fife: *"Song of the Cradleboard,"* 1969; oil on canvas; courtesy of the artist.

Phyllis Fife: *"The Poet in Painter's Clothing,"* 1977; oil on canvas; 60 × 72 in.;
courtesy of the artist.

Harry Fonseca was born in 1946 in Sacramento, California, of Nisenan Maidu Indian, Portuguese, and Hawaiian ancestry. He attended the California State University of Sacramento, where he majored in fine arts with emphasis on primal styles and forms. He works in numerous media including oil, acrylic, graphics, and sculpture, in an effort to express aspects of the Indian culture within his contemporary vision. "For the past few years," the artist says, "I have been portraying my concept of the sacred dances of the Native California Indians. I have also recently completed a series of paintings and drawings depicting the Maidu 'Story of Creation'—the 'Creation' has taken three years to complete and was sponsored in part by a grant from the California Arts Council."

Fonseca is currently working on a series of paintings representing a pervasive Native American animal power, Coyote. His painting "Coyote Woman #12" won the Best of Show at the group show at the Wheelwright Museum in Santa Fe entitled "Indian Art Now—1978." "I believe my Coyote paintings to be the most contemporary statements I have painted in regard to traditional belief and contemporary reality. I have taken a universal Indian image, Coyote, and have placed him in a contemporary setting."

During 1978–79 Fonseca was business manager of the Shingle

Springs Rancherias tribal council, struggling to get water and utilities on the Indians' land. He also teaches Native American art to the children and adults of his local school district, a project funded by the California Arts Council.

"For me, what I have to say about art means little in comparison to what I put on canvas."

Harry Fonseca: *"Coyote Meets the Lone Ranger in a Painted Desert," 1978; acrylics and glitter on canvas; 30 × 40 in.; courtesy of the artist.*

Harry Fonseca: *"Coyote No. 43,"* 1979; acrylics on canvas; 24 × 36 in.; courtesy
of the artist.

Carl Gawboy, a member of the Bois Fort Band of the Minnesota Chippewa, was born in 1942 in Cloquet, Minnesota. Most of his life has been spent in northern Minnesota. He attended Ely High School and was graduated from the University of Minnesota at Duluth in 1965. He received a master's degree from the University of Montana in 1972. Gawboy has taught art in high schools and colleges and served as a museum intern for the 1972 Walker Art Center exhibition "American Indian Art: Form and Tradition." He is currently on the staff of the Indian Studies Department at the University of Minnesota, lectures on Native American art, and owns the Bois Fort Gallery in Ely, Minnesota. He is one of the most brilliant of Indian genre painters.

"My style of painting is close to that of Andrew Standing Soldier, Allen Sapp, and Godfrey Broken Rope. We attempt to paint, with dignity, the everyday world of contemporary Indian life of our region. I don't believe that this style evolved as a reaction to Traditional Indian painting. To the contrary we came out of another idiom—Regional Realists. And we have subsequently developed a style with which we are comfortable. I know that many of us who paint in this idiom were self-taught and were never exposed to

Carl Gawboy: *"Ricers Resting,"* 1977; watercolor; 15 × 22 in.; courtesy of the artist.

Indian art styles prominent in the Southwest and in Oklahoma. My personal awareness of my place in North American Indian art came about in 1973 when I won a third prize in watercolor at the Scottsdale National Indian Arts exhibit. That was when I realized my work was 'Contemporary' in the Indian sense of that work. In that exhibit there were only a few other artists handling watercolor in the transparent washes which I had been using. Most of the paintings at Scottsdale used the opaque watercolor style typical of the Traditional idiom. I saw Harrison Begay's 'Deer in Moonlit Forest' at the exhibit, and I was absolutely stunned. I realized then what a great style the Traditional idiom really is. And I hope that idiom remains with us for many years to come.

"The first Indian artist whose work I studied was Patrick Des Jarlait, the great Minnesota Chippewa artist, now deceased, who dealt with the everyday world of my region. His work began to get popular in the 1960s, but I have to admit that I really didn't like it. I thought it was much too idealized. Since my 'angry young man' days, I have had a change of mind about Des Jarlait. I think he was a genius. He painted both traditional and contemporary Chippewa subjects; no one else was doing that at the time, and no one has done it as well since.

"I was raised in rural St. Louis County, in Northern Minnesota. Most of the scenes I paint came from my years as a child, and these

are painted from memory. Other scenes, like those of the fur trade era, are the result of research. My main theme is the land and the people of Northern Minnesota. I also paint white ethnic and immigrant scenes, insofar as I believe that the land has shaped all of us. No people are strangers to the land when they give their life to it. After all, the land is what is important. It goes on."

Carl Gawboy: *"Chippewa Duck Hunters,"* 1978; *watercolor; 8 × 11 in.; courtesy of the artist.*

Carl Gawboy: "*Lowering the Flag, Ball Club, Minnesota,*" *1978; watercolor; 18 × 24 in.; courtesy of the artist.*

Carl Gawboy: "*Harvest Moon,*" *1975; watercolor; 22 × 30 in.; courtesy of the artist.*

Carl Gawboy: *"Cree Fiddler," 1978; watercolor; 15 × 22 in.; courtesy of David Beaulieau, Minneapolis.*

BILL GLASS, JR.

Bill Glass, Jr., is a Cherokee Indian born in 1950 in Tahlequah, Oklahoma. From his experiences in 1973 at Central State University in Edmond, Oklahoma, Glass became interested in the field of ceramics. He continued his studies in Santa Fe at the Institute of American Indian Arts, where his efforts in innovative ceramic forms broadened to include an interest in sculpture. After leaving the Institute in 1975, Glass returned to Oklahoma and began a two-year term as arts and crafts director for the Cherokee Nation of Oklahoma. Today Bill Glass lives in Oklahoma, where he devotes himself entirely to his art.

Works by Glass have been exhibited at the Heard Museum, the Philbrook Annual Competition (where he won the Jerome Tiger Memorial Award in 1975), and the Bicentennial Exhibit at the Gilcrease Museum, Tulsa, Oklahoma.

"When I am working in a contemporary style I try to create movement with abstractions. I hope the result has some sort of freshness. I use design to bring about an exciting response. I try to pull out all the tricks available to me that will help bring a piece to life. At this time my major interest is high-fired ceramics. It is a very demanding field and a science in its own right. I try to control the clay without dominating it . . . to let its spirit coincide with mine."

Bill Glass, Jr.: *"Hairdo,"* *1978; ceramic stoneware; 8 ×* *9 × 4 in.; courtesy of Lacreda* *Supernaw; photograph by* *Knokovtee Scott.*

Bill Glass, Jr.: *"Whispering Winter Winds," 1978; Georgia marble; 9 × 2 ×* *7 in.; courtesy of the artist; photograph by Knokovtee Scott.*

Ric Glazer is a Mohawk Indian of the Caughnawaga Band of the Iroquois Nations, born in New York State in 1942. Before turning to painting, he was a structural ironworker, as were his father and grandfather. Along with many other Mohawks, Glazer worked on many high-rise buildings on the East and West coasts of America. In 1970 he successfully turned his attention to a career as a painter, earning his B.F.A. degree from California State University in Chico, where he was graduated in 1972. In 1978 he received an M.F.A. degree from the University of California at Davis, where he now lectures in the American Indian Studies program.

Glazer feels that his paintings depict a contemporary rather than a nostalgic view of Indian life.

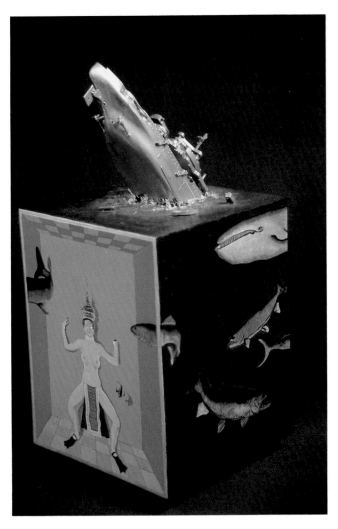

Ric Glazer: *"Deep Six" (two views), 1978; oil, acrylics, enamel and plastic; 18 × 18 1/2 × 8 1/2 in.; courtesy of the artist.*

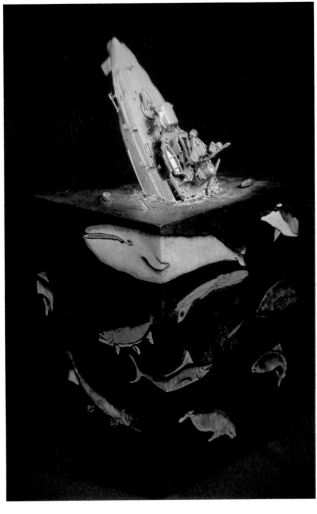

Henry Gobin was born in 1941 on the Tulalip Indian Reservation in Washington State. His academic career was brilliant: Between 1962 and 1965 he was a student at the Institute of American Indian Arts, where he now paints and teaches; and in 1970 he took his B.F.A. degree from the San Francisco Art Institute. Shortly thereafter he was voted to immediate candidacy at Sacramento State College to receive a master's degree in one year, 1970–71. He worked as a teaching assistant in the fields of drawing, watercolor, and oil painting.

Gobin has been widely exhibited at such galleries as the Los Llanos Gallery in Santa Fe, where his work can be regularly seen, the Heard Museum in Phoenix, the Philbrook Art Center in Tulsa, and the Gallery of the University of San Francisco. Two recent awards of importance were the 1974 Third Prize in Watercolors at the Annual Contemporary Indian Art Exhibition in Washington State and honors at the 1977 Heard Museum Painting Competition Show.

"I am a product of the old Santa Fe Indian Boarding School and the flat two-dimensional style of painting that has been indicative of the Southwest; this was from 1960–62. While I consider myself very

fortunate to have had the opportunity to be exposed to that style of painting, I come from the Tulalip tribes on the Puget Sound in the Northwest Coast, which, to me, was a very different time and place. The flat two-dimensional style did not fully meet my personal needs. Then the Institute of American Indian Arts took over the same classrooms in 1962 that once had been occupied by the traditional program of the Studio, and it was there that I was given more freedom to explore other media at a deeper level. I dare say, I received very little formal instruction from the Institute's painting teachers. It seemed as though everything I did went against the accepted norms at that period of time. My interests were focused on ceramics, painting, and printmaking as well as helping to establish for the first time various theatrical conventions for the development of Indian theater.

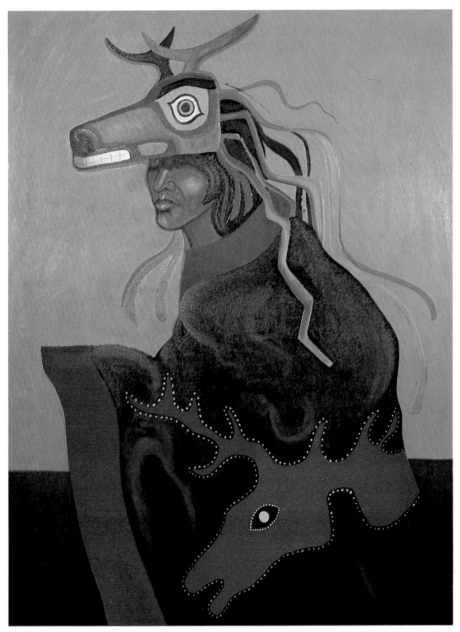

Henry Gobin: *"Deer Dancer," 1978; oil on canvas; 38 × 50 in.; courtesy of the artist.*

"That all came to an end when I went to the San Francisco Art Institute in 1965–71. What a period to be in college!—Watts riots, Berkeley Free Speech Movement, San Francisco State College demonstrations, not to mention the political reaction to Vietnam and the takeover of Alcatraz Island by Indians. It was during that time, in 1966, that I got involved in Happenings and the Theater of the Absurd. I worked with people like author Leonard Cohen, professor John Collier, and the poet Bill Witherup. During 1968–69, I was called a surrealist. I was simply doing painting with organic movement, floating in space or underwater paintings—or so they appeared.

"Things in my life have now calmed down and I'm doing stylized faces and masks of the extreme Northwest Coast. There is still an element of surrealism in my current paintings, but not as pronounced as before. I feel as though I'm just beginning to appreciate what life is about and just beginning to learn how to paint."

Henry Gobin: "*Mask Coming Apart from Us,*" *1971; watercolor; 22 × 30 in.; courtesy of the artist.*

R. C. Gorman, a Navajo, was born in 1932 at Chinle, Arizona, on the Navajo Reservation. His father was the painter Carl Gorman, who studied after World War II at the Otis Institute. Although R. C. Gorman majored in literature at Arizona State University, he chose painting as a career. His depictions of Indian women, done with monumental simplicity, are among his best paintings. As Dr. Frederick J. Dockstader points out, "Gorman has been experimental and uninhibited with his art and was one of the earliest to break out of the old-style Indian School art shell and to create a bridge between the Traditional and the avant-garde. He has developed to a point where he now owns and operates the Navajo Gallery in Taos, one of the very few Native Americans to own his own art gallery." Gorman has produced in a wide spectrum of idioms, including his depictions of Indian women, a series of exquisite geometric canvases based on Navajo blanket designs, nudes, a variety of graphics, and, most recently, sculpture and bronzes.

R. C. Gorman's art shows a strong Mexican influence, probably the result of his being awarded a Navajo Tribal scholarship to study art at Mexico City College (University of the Americas), where he became familiar with, and impressed by, the works of Orozco, Siqueiros, and Rivera, all of which continue to influence his work along with traditional Navajo themes and designs.

"I have been quoted as being very much against Traditional painting. That is not correct. Not at all. What I'm against is young Indians who start to paint Traditionally when they should be exploring other ways of expressing themselves instead of simply doing what has been already done many times before. I'm complaining about their lack of originality and personal pride in their own imagination. The old people, that was their form of art. They invented it. Why shouldn't they paint in the Traditional manner? But the young—that's a very different matter. Today is another day and we have to learn now to paint in terms of ourselves. I do this my way and Fritz Scholder does it in his. That's as it should be. But ultimately what is important is liking art and realizing that it is a very personal part of an artist, like his feelings and his ideas."

R. C. Gorman: *"Seated Lady," 1978; oil pastel on paper; 22 × 28 in.; courtesy of the artist.*

R. C. Gorman: *"Duo-Rug Motif,"* 1974; *acrylic on canvas; two panels; 70 ×
54 in.; collection of Mr. and Mrs. Robert Scribner-Ruidoso, New York; courtesy of
the artist.*

HA-SO-DE (NARCISO ABEYTA)

Ha-So-De is a Navajo born in 1918 in Cononcito, a small Indian community thirty miles west of Albuquerque. His Navajo name, Hoskiel Ha-So-De, means "fiercely ascending," and he has always signed his work in this native form rather than with his Hispanic name, Narciso Abeyta.

Ha-So-De has been painting since the 1930s, when he was a student at the original Studio of the Santa Fe Indian School, where he studied under Dorothy Dunn. From the outset of his career in art, he has been evolving a highly individual style, a preoccupation so rare among Studio students that Dorothy Dunn noted from her first acquaintance with him that he possessed "a markedly individual style."

Without controversy or notoriety, Ha-So-De moved resolutely away from the Traditional style of the Studio and produced an uncommonly unified and strikingly original tradition of his own. He is clearly one of the founders of the individualist focus of Contemporary North American Indian painting, but, unlike Oscar Howe, Fritz Scholder, or Norval Morrisseau, his career in art faltered after a brilliant and early beginning. At the age of sixteen he illustrated Hoffman Birney's book, *Ay-Chee, Son of the Desert.* In 1938 his poster, "The Sun Carrier," was selected by the 17th Annual

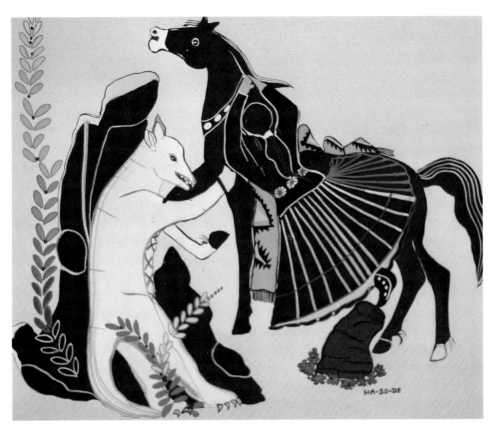

Ha-So-De: *"Werewolf," 1970; casein on paper; 20 × 24 in.; courtesy of G. Seely and the artist.*

Inter-Tribal Ceremonial Competition in Gallup to publicize that major cultural event of the Southwest. In the same year he was awarded Second Prize for his Golden Gate Exposition poster. The prestige of Indian painters, however, was nonexistent in those days, and Ha-So-De was unable to depend on his art as a source of livelihood. He could only paint as a devoted hobbyist between 1935 and 1942, when World War II interrupted his work and prevented him from accepting a scholarship to Stanford University. When he was discharged in 1946, he was suffering from shell shock. For ten years he gave up painting entirely. But art was an essential ingredient of his life, and he could not stay away from it. In 1948, under the GI bill, Ha-So-De entered the University of New Mexico, where he studied under Raymond Jonson, the Anglo artist who was one of the major forces in the introduction of modernism to Indian painters. Ha-So-De received a degree in Fine Arts from the University of New Mexico in 1952, and in the autumn of that year he moved to Gallup and began working for the State Employment Commission.

During the 1950s and 1960s, Ha-So-De strived diligently but rather inconspicuously in his art, winning a few prizes and then going back to his workaday job in Gallup. Today's ascending

fortunes of Indian art, however, have brought new attention to this splendid Navajo artist, whose style and sensibility are unique and whose expressiveness is so devotedly Indian. There is little question of the truth in the prophecy of his teacher, Dorothy Dunn: "Ha-So-De has the capacity to yet return as one of the strongest leaders in contemporary Indian art."

Ha-So-De: *"Fire Dance," 1973; casein on paper; 19 1/2 × 22 in.; courtesy of G. Seely and the artist.*

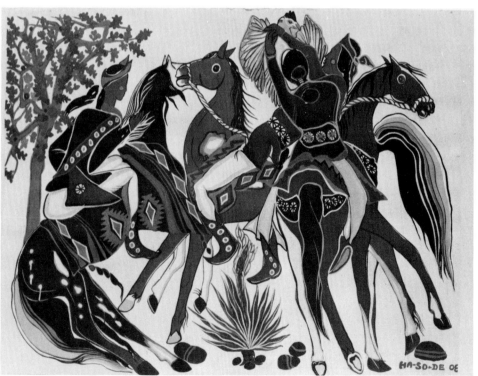

Ha-So-De: *"Chicken Pull," 1972; casein on paper; 21 1/2 × 28 in.; courtesy G. Seely and the artist.*

Ha-So-De: *"Night Chant," 1977; casein on paper; 22 × 30 in.; courtesy G. Seely and the artist.*

Ha-So-De: *"Ceremonial Antelope Hunt," 1976; casein on paper; 29 1/2 × 22 in.; courtesy N. Thayer and the artist.*

James Havard is a well-known artist of the 1970s, whose paintings are not generally identified with so-called "Indian art." His work is regularly shown by the Louis K. Meisel Gallery in New York and is included in several major collections there, such as the Guggenheim Museum and the Whitney Museum of American Art. He is a leader among "Abstraction Illusionists"—a style of painting that has attracted some attention recently and that is also reflected to a degree in the work of another Native American painter, George Longfish.

Havard was born in 1937 in Galveston, Texas, and was educated at Sam Houston State University in Huntsville, Texas, and the Pennsylvania Academy of Fine Arts in Philadelphia—a city in which Havard is especially well known and much honored. His work is in the collections of the Philadelphia Museum of Art. He has had one-man shows in many galleries in the United States, Canada, and Europe. He currently makes his home in Philadelphia. He is a Chippewa/Choctaw Indian by heritage, and his work reflects in its titles and imagery various distinctive Native American elements.

James Havard: *"Chippewa," 1976; acrylics on canvas; 48 × 48 in.; courtesy of Louis K. Meisel Gallery, New York.*

Joan Hill, born in Muskogee, Oklahoma, counts among her ancestors Cherokee chiefs and Creek kings. Her Indian name, Chea-se-quah, means "Redbird." Her studio is located on the site of Fort Davis, her family home since the 1800s. After graduating from college, Joan Hill taught in the Tulsa, Oklahoma, public school system for four years before resigning in order to study and paint full-time. Among the 234 awards she has won is the Waite Phillips Special Artists Trophy. Her traditional and contemporary paintings are in the permanent collections of the U.S. Department of the Interior, Washington, D.C.; the Philbrook Art Center, Tulsa; the Heard Museum, Phoenix; and the Museum of the American Indian, New York. Joan Hill is one of the few Native American artists who has successfully worked in both the Contemporary and Traditional idioms, and, along with the Navajo R. C. Gorman, she has experimented in the depiction of the nude—a subject that rarely appears in Indian art.

"Art exists for me not to reflect reality as it is, but to create some other reality. Through my paintings I wish to transform my visual conceptions into a material form which can be shared with the world. Art widens the scope of the inner and outer senses and enriches life by giving us a greater awareness of the world."

Joan Hill: *"Evening of the Busk,"* *1969; oil on canvas; 30 × 40 in.; courtesy of* *the artist.*

HOMMA (SAINT CLAIR HOMER II)

Homma (Saint Clair Homer II) is the son of a German mother and a Choctaw father. He was born and raised in Oklahoma in the early part of this century. He had extensive academic art training, attending James Millikin University in Decatur, Illinois, and, after serving with General Patton in Europe during World War II, Biarritz University in France. In Rome, Homma attended seminars in modeling and casting techniques. After returning to the United States, he studied at Oklahoma State University, Missouri University, and the University of Oklahoma in Norman. For a number of years Homma cast his own models; today, however, most of his bronzes are cast in Rome. He signs his work *Homma*, which in the Choctaw language means "Proud Red."

As Patricia Janis Broder has commented in her book on American bronzes, "Homma's sculpture has evolved from narratives of the West to poetic creations which express the dreams and desires of the Indian. These bronzes have the spiritual intensity that is the soul of Indian sculpture. His finest sculpture is 'The Star Shooter,' of which the artist himself has said, 'This piece evolved from a bit of legend; man's constant striving for perfection and possibly his curiosity about nature, with which the Indian is so akin.' "

Homma celebrates each June 25 by sending out greeting cards of his own design that commemorate the defeat of Custer at the Little Big Horn in 1876.

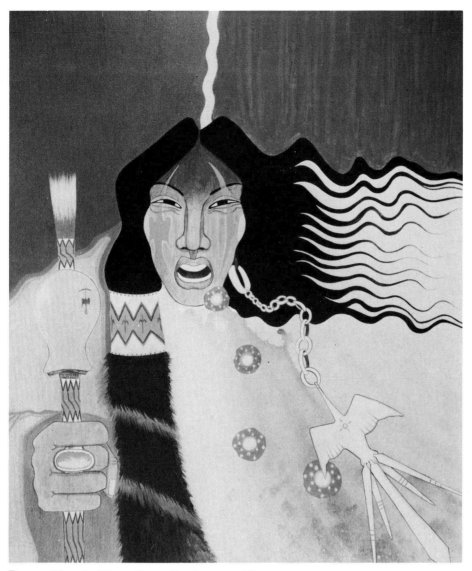

Rance Hood: *"Four Songs,"* 1978; *acrylics on canvas; 35 1/2 × 47 1/2 in.; courtesy of Tribal Arts Gallery, Oklahoma City.*

has often shifted from the nostalgic vision of the pre-Columbian Indian to the "street" Indian of his own day. Falteringly he has commenced exploring the potential of media alien to Traditional painters: canvas, acrylics, etc. With a carpenter's hammer and a large screwdriver he set to work one day on a block of marble as if he had been sculpting all his life. He quickly showed the same vital and expressive capacity in stone as he possesses in paint. He is clearly one of the avowed Traditional Indian artists who are gradually finding their own unique way into mainstream art without giving up any of their fierce love of custom and tradition.

"The picture is painted in a swirling, circular motion; this is the Indian way. It is the basic movement of all things: the movement of the earth, wind, the great circle of the sky. This is the very essence of life itself, the pathway of all spiritual things. A natural understanding of this is born into all true Indian artists and

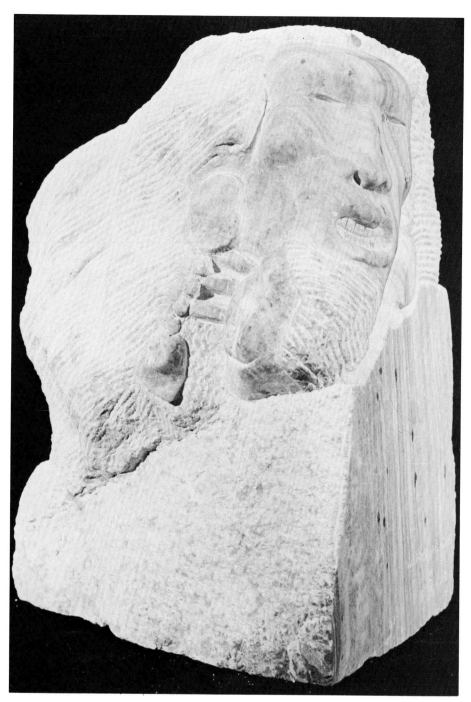

Rance Hood: *"Warrior and Child,"* 1978; marble; h. 15 in.; courtesy of Tribal Arts Gallery, Oklahoma City.

craftsmen. There is an instinctive point of origin—and as the wind blows and as life revolves, the painting or the beadwork comes easily back around to its point of origin and its point of ending. No special plan or design is used to bring this about; it simply happens, because this is a natural way—our way. A painting style is a matter of feeling . . . of mood. I am Comanche; my people were a hunting, warring people, nomads, great horsemen. They were a proud people, a wild people alive and ever-changing like the land and the seasons. My painting style changes too. It explains itself. I am Comanche."

JOHN HOOVER

John Hoover was born in 1919 in the small town of Cordova on the southeastern coast of Alaska, the son of an Aleut mother and a father of German descent who died when Hoover was six years old. The future artist grew up with two sisters, one a concert violinist before she was eighteen (the age at which she died of leukemia) and the other skilled in art. Hoover was fascinated by her drawings. "I thought it was a form of magic and tried to copy her," he explained in a recent interview. Another early influence was the painter Eustace Ziegler, rector of the Episcopal church in Cordova.

After excelling in art in school, he served in the U.S. Army Transportation Service from 1942 to 1945, operating boats in Alaska. In 1948 he married and settled into the life of a commercial fisherman and shipwright. He has five children.

During 1950 Hoover began exploring the expressive possibilities of painting, drawn to the "magic" he had watched his sister conjure as a child. In 1952, when he moved his family to Edmonds, Washington, he started taking art classes during the winters when he was laid off from his job in the commercial fishing industry. Hoover gradually came into his own as a painter. Studies during 1967 with Leon Derbyshire of the School of Fine Arts in Seattle helped to focus his talents. And although painting was his principal interest,

he also became fascinated with another art form. In 1958 he and a friend in Edmonds had built a fishing boat in the backyard of the Hoover home. Lacking professional power tools, Hoover had shaped many of the wooden fittings by hand. "Every piece of wood that goes into a boat is sculptural in form," he recalls. "I became intrigued with the idea of wood sculpting."

In the early 1960s he began to produce two-dimensional plaques very much in the Traditional Northwest Coastal style. By 1965 he had his first major sculpture show at the Collectors Gallery in Bellevue, Washington. In 1972 Hoover received his first major art award, a First Award in sculpture at the Annual Contemporary Indian Art Exhibition at Central Washington State College. At the prestigious Sculpture I, II, and III Invitationals of the Heard Museum in Phoenix he won two Silver Medals and a Purchase Award. In 1975 he received a First and Second Award at the Heard Museum Guild's Annual Indian Arts and Crafts Exhibition and in 1977 a First in wood sculpture from the same institution. He also was awarded a First Place in sculpture at the Philbrook Art Center (Tulsa) in 1974 for his cedar triptych entitled "Otter Daughter."

In 1972 a grant from the National Endowment for the Arts gave him the exceptional opportunity of working with Allan Houser at the Institute of American Indian Arts in Santa Fe.

"The creation of images has become a very serious and important part of my life. A religious aspect has crept slowly to the fore. A closer contact with, and a clearer understanding of, Shamanism, a deeper search within my own consciousness, being more aware of Nature—all these things are part of the search for fulfillment which eventually resolve in my art form and style. I would hope that these values are passed on to a viewer and that people who associate with my work on a more personal basis are somehow benefited by these good things I feel, and can share in the peace and harmony I derive from creating them."

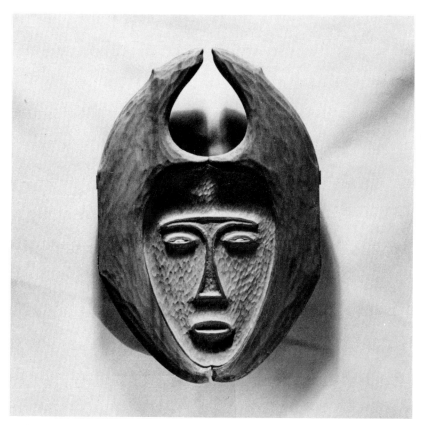

John Hoover: *"Polar Bear triptych,"* 1978 *(shown closed and open); red cedar; h. 24 in. courtesy of the artist; photograph by Mary Randlett.*

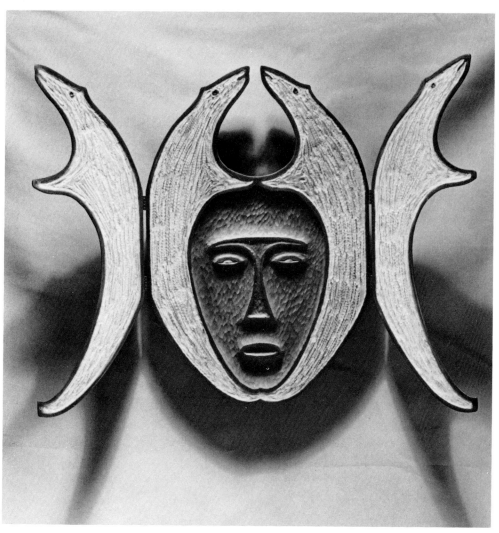

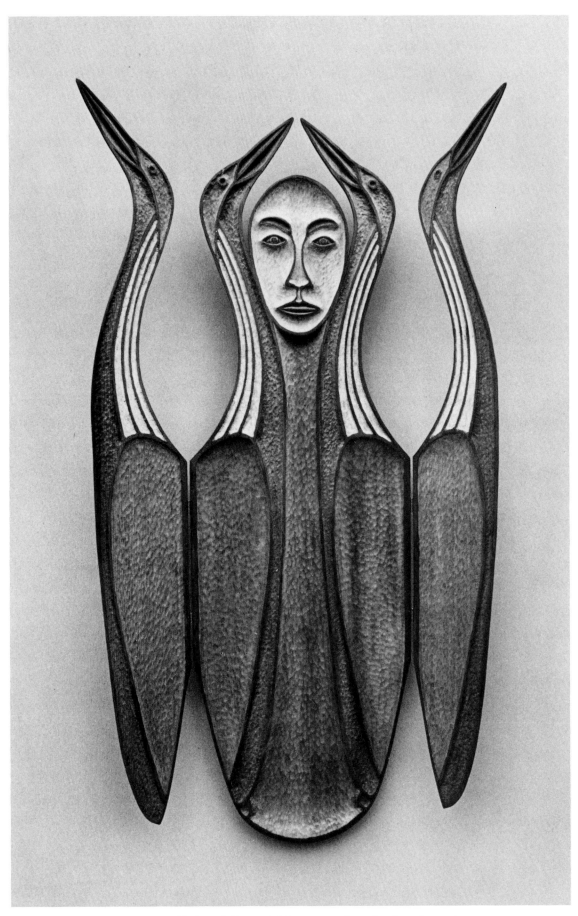

John Hoover: *"Cormorant Triptych," 1976 (shown open); red cedar; h. 36 in.; courtesy of the artist; photograph by Mary Randlett.*

Allan Houser is widely recognized as the leading North American Indian sculptor. Born in 1914 in Apache, Oklahoma, his Chiricahua Apache name is Haozous ("Pulling Roots"). His granduncle was Geronimo, who was imprisoned at Fort Sill, Oklahoma, where he died and was buried. Houser's parents were also taken to Fort Sill and held prisoners with Geronimo's band. Later, after his father started to farm, young Houser helped at home and attended school only intermittently. He began painting in the Traditional manner about 1924 after a childhood of great hardship. Midcourse in his career as a painter, Houser became increasingly interested in sculpture and has devoted most of his time during the past decade to sculpting.

Houser's education was centered at the Studio in Santa Fe, where he trained under Dorothy Dunn. His painting was devotedly Traditional in idiom—though he reports controversies with Dunn over his artistic right to pursue his own intuitions about painting. Sculpture has brought out an experimental side of Houser's temperament. Since 1962 he has taught sculpture and painting at the Institute of American Indian Arts in Santa Fe, where he now makes his home. He was the recipient of the Palmes d'Académiques from the French government for his contribution to the advancement of

Indian art. Today he is generally regarded as the most influential Indian sculptor and teacher in the United States.

"I put everything that I have into all that I do, and if it's not right, then you won't see it on the market. I use all that I know, for I feel that I must progress, I must not stay in one place. Growing up with Dad, hearing him talk, I've kept a strong feeling for my people. He relived the early days. People came from all over to hear him sing—not for his voice but for his memories. He knew all of Geronimo's medicine songs. I can remember old people with tears running down their cheeks when he sang about things they remembered. Being around my Indian friends makes the difference in my life and in my art. I tell my students, 'Be an Indian but allow something for creativity too.' "

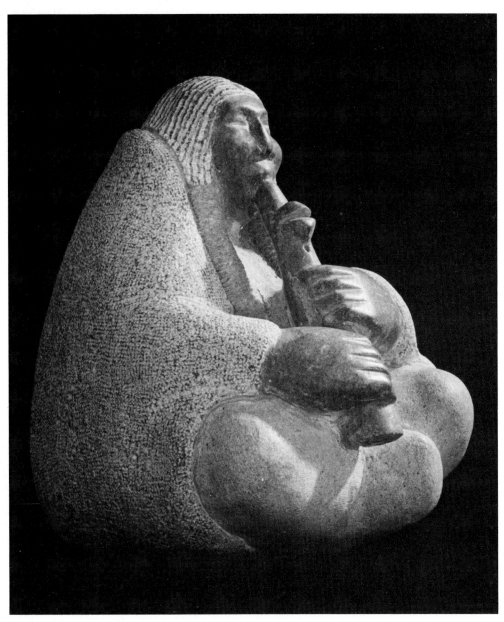

Allan Houser: *"The Flute Player," 1976; pink marble; h. 15 in.; courtesy of Marshall Wax and The Gallery Wall, Phoenix.*

Allan Houser: *"Taos Man,"*
1978; bronze; h. 13 1/2 in.;
courtesy of The Gallery Wall,
Phoenix. *"Repose,"* *1979;*
bronze; h. 7 in.; courtesy of
The Gallery Wall, Phoenix.

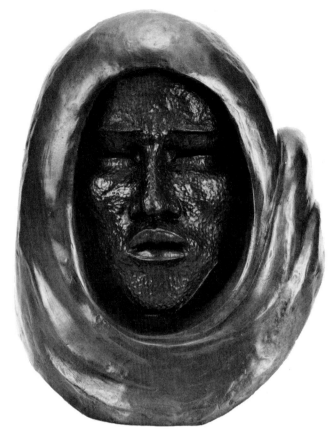

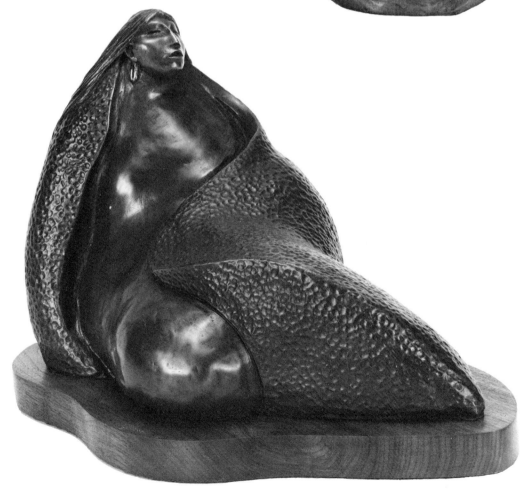

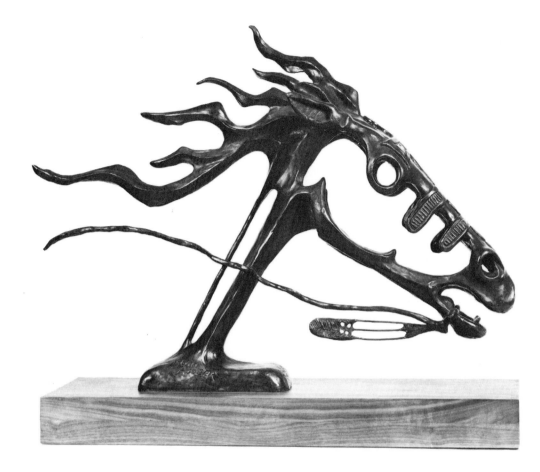

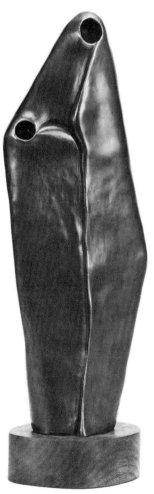

Allan Houser: *"War Pony,"
1978; bronze; h. 24 in.; cour-
tesy of The Gallery Wall,
Phoenix. "Sheltered," 1979;
bronze; h. 15 in.; courtesy of
The Gallery Wall, Phoenix.*

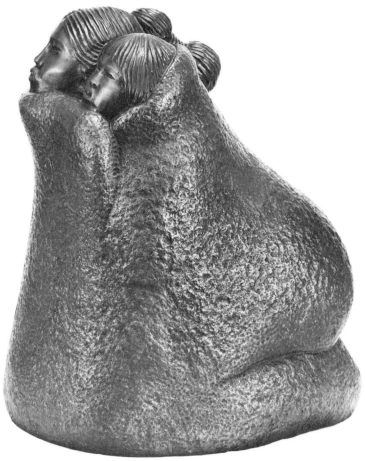

Allan Houser: *"Watching the Dance,"* 1979; bronze; h. 13 3/4 in.; courtesy of *The Gallery Wall, Phoenix.*

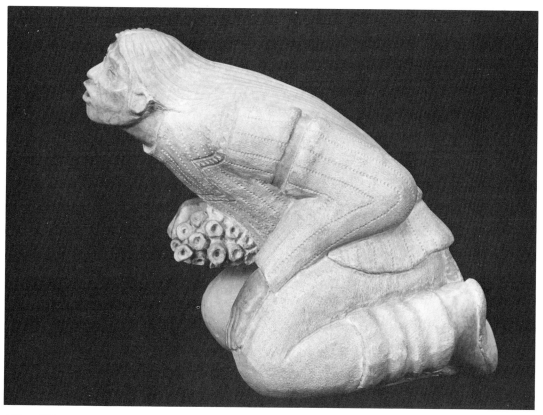

Allan Houser: *"Healing Chant,"* 1979; alabaster; h. 13 1/2 in.; courtesy of The *Gallery Wall, Phoenix.*

Oscar Howe is one of the seminal forces of Traditional American Indian painting and the major impetus from which the Contemporary school of Indian art arose. He was born in 1915 at Joe Creek, on the Crow Creek Indian Reservation of South Dakota, and is a full-blood Sioux Indian. His parents were George T. Howe and Ella Not-Afraid-of-Bear. His paternal grandparents were Grandfather Don't-Know-How, and Great Grandfather Bone Necklace, head chief of the lower Yanktonai Band of the Sioux. Oscar Howe's maternal grandparents include the Yanktonai chief Grandfather Not-Afraid-of-Bear and Great Grandfather White Bear.

Howe attended the Pierre Indian School until 1933. In 1938 he completed his high school education at Santa Fe Indian School. His first studies in art were at Santa Fe under the direction of Dorothy Dunn. Even before his graduation, Howe had already exhibited paintings in such major centers as New York, San Francisco, London, and Paris. For a time he was art instructor at the Indian School in Pierre, South Dakota. During the same period he served in the South Dakota Artists' Project and was later commissioned to paint ten murals for a new auditorium at Mobridge, South Dakota.

During World War II, Oscar Howe spent three and a half years in the U.S. Army in Europe. While serving in Germany, he met

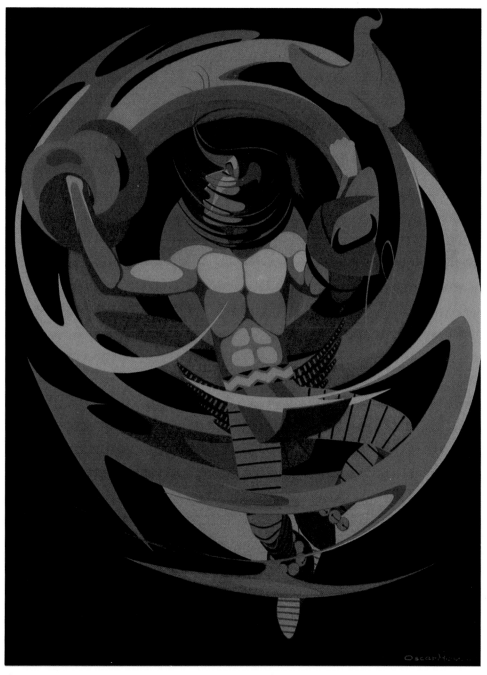

Oscar Howe: *"The War Dancer," 1971; casein on paper; 28 × 33 in.; courtesy of the University of South Dakota, Vermillion.*

Heidi Hampel, who later became his wife. They have one child, Inge Dawn, born in 1948.

After the war Howe was commissioned to illustrate a two-volume work, *North American Indian Costumes,* which was published in a famous limited edition in Nice, France, by C. Szwedzicki in 1952. Then in 1948 Howe was selected as artist-in-residence by Dakota Wesleyan University, where he was an instructor while working toward his undergraduate degree. He received his M.F.A. degree from the University of Oklahoma in 1952, and in 1953 he became director of art at the high school in

Pierre, South Dakota, a position he held until his appointment in 1957 as assistant professor of fine arts and artist-in-residence at the University of South Dakota. It is from the excellent collection of the galleries of the University of South Dakota in Vermillion that these previously unpublished works by Oscar Howe were drawn. Today he is professor of art and artist-in-residence at the university.

In 1973 a film entitled *Oscar Howe, Sioux Painter* was produced by the South Dakota Arts Council and the University of South Dakota, depicting the artist's life, artistic philosophy, and his many paintings.

Among the countless awards won by Oscar Howe are fifteen grand prizes and the Waite Phillips Trophy for outstanding contributions to American Indian Art. He is Artist Laureate of the State of South Dakota and holds an honorary doctor of humanities degree among his many honors. In 1978 he was the recipient of the National Achievement Award (Golden Bear) presented by the American Indian Art and Cultural Exchange.

" 'The painting of the truth,' a verbal idea transposed to visual form, was the traditional Sioux Indian way of painting. A formal painting was a ceremony in which historical and biographical events were recorded on skins. Such ceremonial paintings decorated tipis and robes or were kept rolled as recorded documents and displayed at special occasions. In the ceremony, the narrator would verbally describe the event while the artist worked precisely from point to point in objectifying what was being narrated. And a selected audience witnessed the ceremony. Its validity depended on the witnessing of the truth translation and the accepted conventions of art as to technique, medium, colors, materials, and the traditional way of painting.

"The skin-painting technique was a flat two-dimensional affair. The delineating lines were simple and short—less plastic and without any shading. The painting style and content were visually exoteric for intellectual identity. The visual lines connect predetermined aesthetic points. The points were established in space during a three-day study before the ceremony by the artist without touching the painting area.

"The colors and meanings taken from nature were basically symbolic: blue sky, peace; red blood, war; yellow earth, religion; white daylight, purity; black night, evil; green growth, flora. . . . Colors came from earth, plants, berries, and other sources. The medium was tempera of water, glue, fats, egg, and color. The application of colors to skin surface with bone brushes were usually flat and quite linear. . . .

"It has been my ambition to revive and preserve Sioux art, but doing this in a way to present the finer points of culture and by Sioux art means. . . . One criterion for my painting is to present the cultural life and activities of the Sioux Indian: dances, ceremonies,

legends, lore, arts, genre. . . . The main purpose of this art is to effect intellectual and emotional experiences respectively by emulating the form with subject. . . .

"The reason for using the painting medium of casein is to align my dimension-form-concept technique with the old Indian skin painting technique. Because of its fluidity in applying colors, long and quick strokes can be made with ease. It is also quick drying for continuous work.

"The method of studying the painting area to established aesthetic points has become a part of my intellectual approach to creative work. My painting is not a ceremony. After studying my

Oscar Howe: *"Weotanica,"* *1975; casein on paper; 29 ×* *38 in.; courtesy of the University of South Dakota, Vermillion (top); "Mythical Bird," 1975; casein on paper; 15 × 25 in.; courtesy of the University of South Dakota, Vermillion (Bottom).*

Oscar Howe: *"Woman Seed Player,"* 1974; casein on paper; 34 × 31 in.; courtesy of the University of South Dakota, Vermillion.

painting space I immediately mark the aesthetic points and connect these with plastic lines of different degrees of curvature. And then to patterns with the final objective form.

"The straight line is a Sioux symbol meaning truth or righteousness. It also means that in the sign language. Movements in nature were interpreted as having linear meanings. The art trends of the Sioux derived from environmental influences in different localities. The curved line movement impressed the Woodland Sioux so it became a symbol for movement and unity in his designs, while the Plains Sioux, being impressed by the wide open sky and flat terrain, was geometric in design with straight lines and open spaces. These lines and their meanings are part of my artwork. . . . My paintings have substantiated my thoughts of giving visual form to the poetry of worded beauty and truth. . . . The idea and practice of individualizing the creative process, technique, and the aesthetic meaning of Indian subject have yielded a style and personal satisfaction."

Doug Hyde was born on July 28, 1946, in Hermiston, Oregon, as Ivan Douglas Hyde, though he prefers the name Doug Hyde and signs his work that way. He is of Nez Perce–Assiniboin descent, and his family originally came from Lapwai, Idaho. His family still resides in Idaho, although he now considers Santa Fe his primary residence. He originally came to New Mexico to study at the Institute of American Indian Arts. He attended that school from 1963 to 1966 and then went on to study at the San Francisco Art Institute, as did many of his classmates from Santa Fe. He served two tours in Vietnam before returning to the IAIA in 1973 as an instructor in sculpture.

In 1974 he decided to go on his own and has been a full-time artist ever since. He has exhibited in one-man shows at the Museum of the Plains Indian (Browning, Montana, 1971) and the Heard Museum (Phoenix, Arizona, 1973), and for the Heard Museum's Sculpture I, II, and III Invitationals in 1973, 1975, and 1977. In March 1979 he appeared in an Indian group exhibit at the Pierre Cardin Gallery in Paris. His awards include a 1973 Gold Medal at the Heard Museum's sculpture exhibition and awards at the National Indian Arts Exhibition (Scottsdale, Arizona) and the Philbrook Art Center (Tulsa, Oklahoma). In 1976 he was awarded Best in Stone,

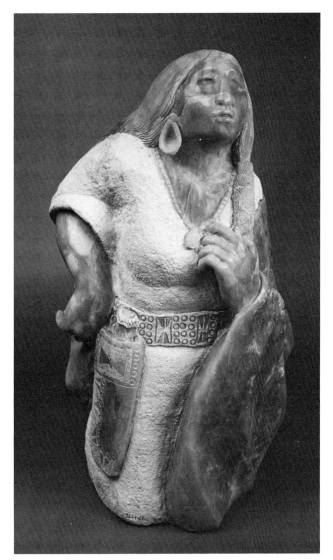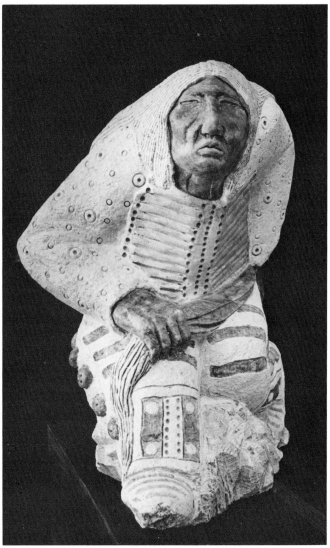

Doug Hyde: "*Near Fort Lapwai,*" *1978; Colorado alabaster; h. 24 in.; courtesy of the Fenn Galleries, Santa Fe (left); "Crow War Dancer," 1977; Colorado alabaster; h. 20 in.; courtesy of the Fenn Galleries, Santa Fe (right).*

Best in Sculpture, and Best in Show at the final Scottsdale National Indian Arts Exhibition. His work is in the permanent collections of the Whitney Museum and the Heard Museum and in numerous collections throughout the nation and abroad.

"I work directly on most of my people and try never to use pre-planned ideas. There are legends in these stones, and the task is to release the images of the old ones and the old things from them. Color and texture are important in the stone, and I try to follow the lines inherent in it and wait for the stone to release its meaning to me. I feel these meanings should not be lost, and maybe my sculptures will help preserve these images of times past, yet show a contemporary way of presenting ideas and stories which have only been handed down previously by word of mouth."

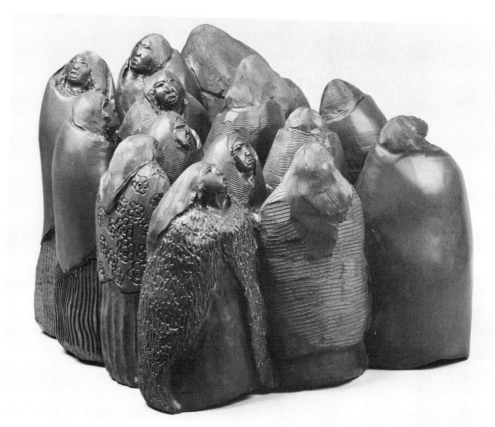

Doug Hyde: *"Plains Shawl Dancers,"* 1978; *African wonder stone; 27 in. long;
courtesy of the Fenn Galleries, Santa Fe (top);* *"Meadowlark tells Grandmother
Coyote is stealing her salmon,"* 1978; *Colorado alabaster; h. 21 in.; courtesy of the
Fenn Galleries, Santa Fe (bottom).*

Conference, and of t
Foundation, New Y

Jemison's cultur
founded a street the
1970; produced a vic
Berkeley, California
and organization of
art experiences. For
inclusion in an exhi
Art.

Jemison's painti
1969. He has also ill
the American Nation,

"I regard it as a
that this society has
can see and feel its
the buds of this pla
some land to plant

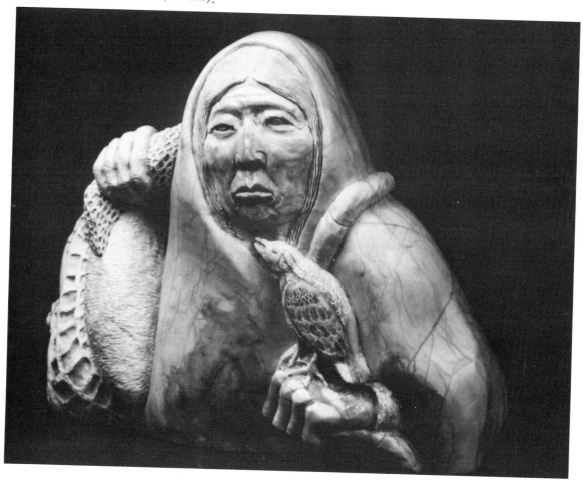

planting I discussed with my father and an elder of the Longhouse the best time to plant and what I should say to the earth. My elder friend Johnson Jimerson told me that Senecas used to soak their white corn seeds in water with hollyhock roots. I soaked my white corn seeds as he instructed, and later that same spring when the corn was about two feet tall we had a flood. The combination of all these things made my corn grow over seven feet tall with long, full ears. I knew then that the hoop was complete and why I painted 'Hollyhock.' "

G. Peter Jemison: *"Sand Burr," 1974; acrylics on canvas; 18 × 21 in.; courtesy of the artist (left); "Riderless Horse," 1978; acrylics and oil on canvas; 16 × 20 in.; courtesy of the artist (right).*

G. Peter Jemison,
in Silver Creek, N
Education from th
and Science at Bu
University of Sien
arts under Tom O
Albany.

His activities
experience in art,
Associates in both
activities as a teac
in Buffalo, New Y
Schenectady, New
Seneca Nation Ed
important posts h
American Indian
Organization for
of the Gallery of

Jemison is ve
a member of the
Organization for

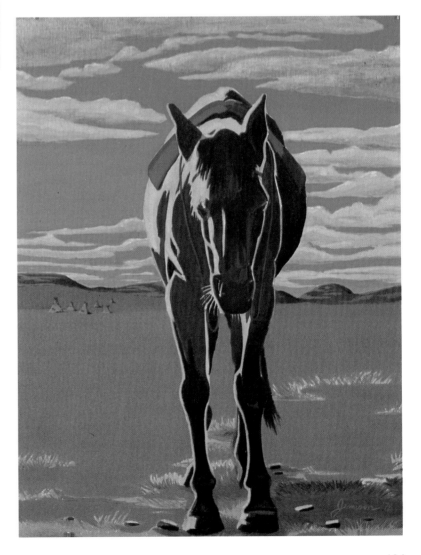

GOYCE AND JOSHIM KAKEGAMIC

The brothers Goyce and Joshim Kakegamic were born in 1948 and
1953 respectively. Cree Indians born on the Sandy Lake Reserve in
Ontario, where Norval Morrisseau grew up, the Kakegamic brothers
were deeply influenced by Morrisseau's Algonquin Legend art and
are, loosely speaking, highly individuated members of that "school"
of painting.

Today the brothers make their home south of the Sandy Lake
Reserve in a town called Red Lake, where they have organized a
studio for the production of large-screen prints.

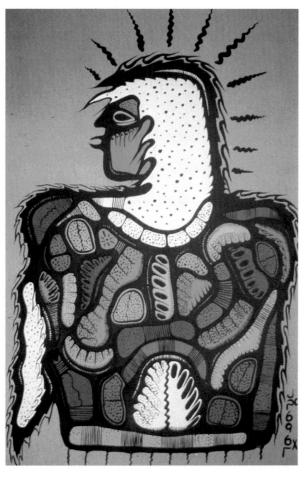

Joshim Kakegamic: *"The Chief,"* 1972; *acrylics on masonite; 33 × 48 in.; courtesy of the Bernhard Cinader Collection, Toronto (top); "Lovers," 1977; acrylics on paper; 30 × 22 in.; courtesy of the Bernhard Cinader Collection, Toronto (bottom).*

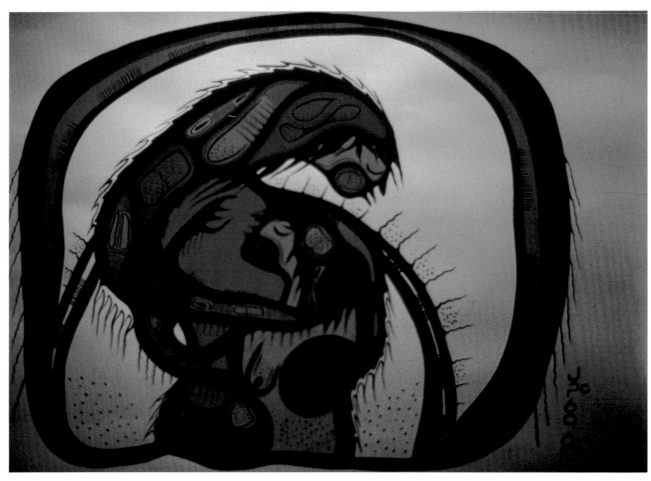

YEFFE KIMBALL

Yeffe Kimball was born in 1914 in Mountain Park, Oklahoma. Her father was the Osage Indian named Other Star Good Man, and her mother was Martha Clementine Smith. Kimball studied at the Art Students League in New York between 1935 and 1939, which makes her one of the first Native American artists to come to terms with the New York art scene. Between 1936 and 1939 she also spent summers studying in Italy and in France, where she briefly worked under Fernand Léger. Her shows have included exhibits at the National Gallery of Art and the Smithsonian Institution (Washington, D.C.), Princeton University, and Trinity College in Hartford, Connecticut.

Yeffe Kimball produced a considerable number of works in a variety of figurative and abstract styles. Besides the energy devoted to her own work, she was a major champion of Indian art generally and Contemporary Indian painting in particular. She was a powerfully persuasive and dignified artist who spoke strongly about her own outstanding works and those of her Indian colleagues in the arts. She single-handedly aroused interest and raised considerable funds for the exhibition of Indian art. She was also active in cataloging Indian art objects, and she organized a great variety of exhibitions that reversed Indian stereotypes and gave realistic

Yeffe Kimball: *"Angry Young Man,"* *1970; acrylics on canvas; 72 × 48 in.;*
courtesy of Dr. Harvey L. Slatin.

emphasis to Native American cultures. She was an outspoken art juror at most of the major Indian art exhibitions and competitions, and her boundless energies were freely given for several years to an organization called INCA, which was concerned with mounting a major international exhibition of Contemporary American Indian art.

Yeffe Kimball died on April 10, 1978.

Yeffe Kimball: *"Satellite Path," 1967; oil on canvas; 36 × 84 in.; courtesy of Dr. Harvey L. Slatin.*

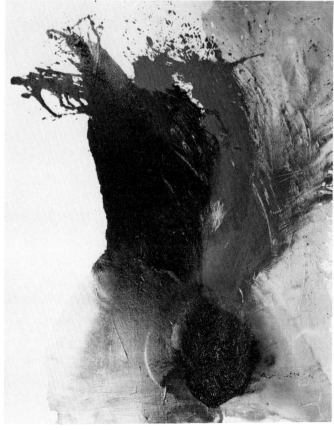

Yeffe Kimball: *"Untitled Drawing," 1941; charcoal on paper, courtesy of Dr. Harvey L. Slatin (left); "Comet Coma," 1961; acrylics on canvas; 70 × 60 in.; courtesy of Dr. Harvey L. Slatin (right).*

King Kuka was born in 1946 on the Blackfeet Reservation in Browning, Montana. Life on the ranch among the mountains is an influence deeply rooted in Kuka and his art. "Simple things which are often overlooked are the subjects which I like most. When painting Indian themes, I try to reveal thoughts or to show simple ideas. I paint predominantly in watercolor in a loose and free contemporary style. When the urge to do something controlled arises, I paint scenes from Montana's abundant landscapes . . . the beauty of the mountains is always a great source of inspiration to me. The mountains are holy to my people and were the Way to the Sun. . . ."

Kuka is descended from the famous Blackfeet chief Mountain Chief by way of his grandfather, an artist who painted Indian portraits and who died when Kuka was only one year old. "I don't remember my grandpa, but he left a suitcase full of oil paints with my mother. That became my first contact with paint. His portraits of long-dead Blackfeet are still inspiring to me."

Kuka's first art experiences occurred during his early school years in a small country school. "I used to draw a lot then. Lots of animals and mountains." When Kuka reached high school age, he left the reservation for the Institute of American Indian Arts in Santa

Fe, graduating in 1965. Afterward he attended the University of Montana, which awarded him a B.F.A. degree.

"Interest in art in the Western world has grown considerably in the past fifteen years. There are hundreds of artists, styles, and media, so competition for a place in the art world is difficult. It will be, however, the art, by virtue of its excellence, that will survive the coming centuries. Thus I can appreciate one of my former art teacher's feelings when he said, 'I want to leave something behind the world will remember.'"

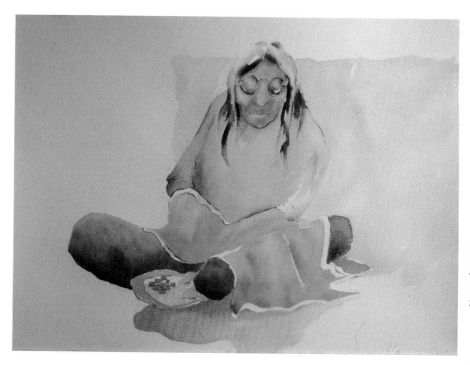

King Kuka: *"Hiding the Bones,"* 1978; watercolor; 22 × 30 in.; courtesy of the artist.

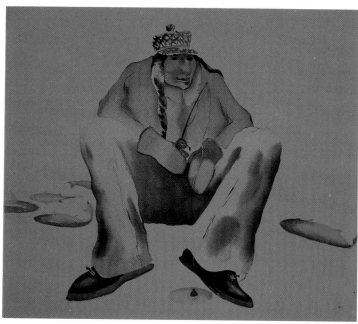

King Kuka: *"Hot Day on Duck Lake,"* 1978; watercolor; 22 × 30 in.; courtesy of the artist.

Frank Raymond Lapena is a Wintu-Nomtipom Indian born in 1937 in San Francisco. Married, with seven children, he is currently living in Carmichael, California.

Lapena attended grade school at the Stewart Indian School in Nevada and the Chemawa Indian School in Oregon. He took a B.A. degree at California State University in Chico; earned a Secondary Credential at California State University in San Francisco; and took his master's degree at California State University in Sacramento. Lapena considers his training with tribal elders and traditionalists and his participation in ceremonies and dances as additional and essential aspects of his education.

His work has been shown in many exhibitions, including those held at the Wheelwright Museum (Santa Fe), Chicago Art Institute, Southwest Museum (Los Angeles), San Francisco Museum, Linder Museum (Stuttgart), American Arts Gallery (New York), and the Oakland Museum.

Lapena is currently the director of Native American Studies at California State University in Sacramento, where he is also an assistant professor of art.

"I believe in the stories and traditions of a mysterious, spiritual

earth; I have been moved by words and music of a song. Art and life are reflections of the spirit and help me understand how things of power relate to the universe. Traditional stories and songs tell of creation and explain the truth of our existence. In song and dance are the designs of tribes and tribal differences. The universe is unlimited, with many thoughts and paths to knowledge. I am seeking to understand my relationship to the universe and my love for the earth and the spirit."

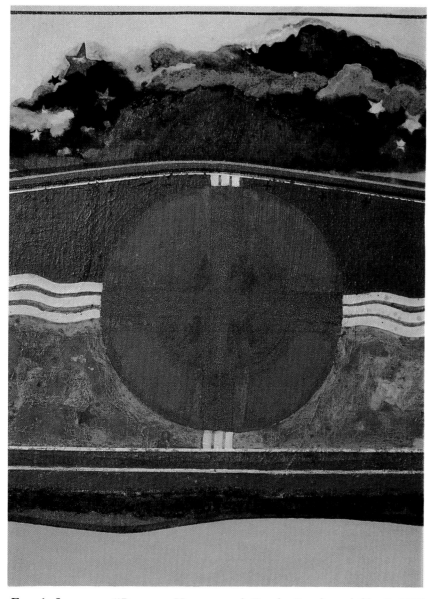

Frank Lapena: *"Between Heaven and Earth; Earth and Sky,"* 1976; *acrylics on canvas; 24 × 18 in.; courtesy of the artist.*

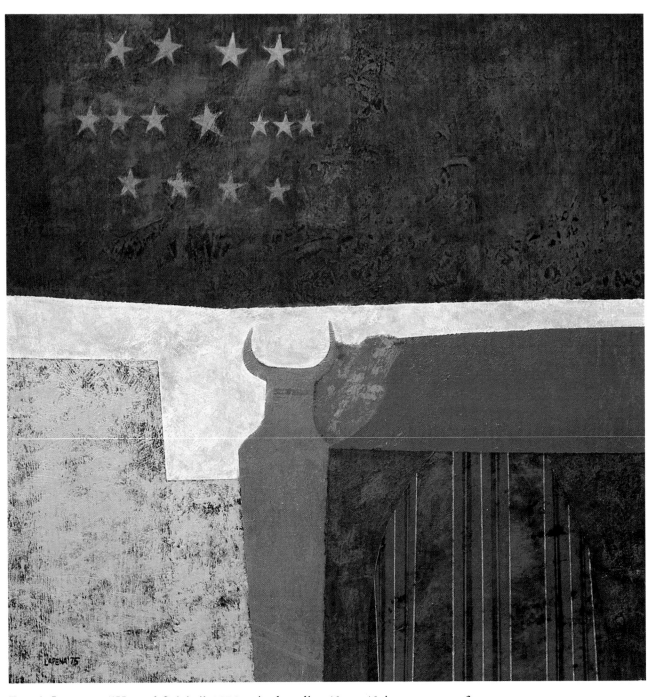

Frank Lapena: *"Horned Spirit,"* 1975; *mixed media;* 48 × 48 *in.; courtesy of*
the artist.

Harold Littlebird descends from Pueblo Indians of Santo Domingo and Laguna in New Mexico. He was born in Albuquerque in 1951 and then moved with his family, first to California and then to Utah, where he remained until 1966. He was then fourteen years old and returned to his native New Mexico to attend the Institute of American Indian Arts, from which he was graduated in 1969. He now makes his home near Santa Fe. Among the numerous awards he has won are First Place in the 1970 New Mexico Craftsman Exhibition, the 1975 Scottsdale National Popovi Day Memorial Award, and the Museum of New Mexico Purchase Award in 1977.

Besides his exceptional and original evocation of the ancient tradition of Mimbres pottery, Harold Littlebird is a well-published poet whose work has appeared in many anthologies and magazines.

"Traditional methods of making Pueblo pottery employ native materials and techniques thousands of years old. I feel I am expanding upon this timeless art with my pottery. Like traditional Pueblo potters, I hand build my work without the use of the potter's wheel. Combining slab, pinch, and coil techniques with ancient designs and motifs, I am exploring old ideas in new and innovative ways. This tradition-blending of the old with the new is achieved by

Linda Lomahaftewa: *"Reflections of the Sun,"* 1978; acrylics on canvas; 48 × 36 in.; courtesy of the artist.

"The subject matter in my work I feel is Indian. I use designs and colors to represent my expressions of being Indian. I think of spiritual aspects of my tribe, and of the American Indian, when I paint. I think of the ceremonies, praying to the sun, and praying for all Indian people for strength and happiness. The colors I employ are sometimes for specific reasons, but basically they relate to my tribal colors of the four directions, and most of the time my colors tend to be painted to my canvas naturally in a contemporary form."

Linda Lomahaftewa: *"Awatovi Parrot No. 1,"* 1979; acrylics on canvas; 30 × 30 in.; courtesy of Dr. Jack Lowrey and the artist. (top); *"New Mexico Cloud Formations,"* 1978; acrylics on canvas; 48 × 36 in; courtesy of the artist (bottom).

Linda Lomahaftewa: *"Pink Clouds and Desert,"* 1970; oil on canvas; 60 × 60
in.; *courtesy of the artist.*

LOMAWYWESA (MICHAEL KABOTIE)

Lomawywesa was born in 1942 in Shungopovi, Arizona, on the Hopi Indian Reservation, son of the renowned Hopi Traditional painter Fred Kabotie. Lomawywesa was one of three founding members of the Contemporary group of painters called Artists Hopid, for which he serves as spokesperson. He received his education at the Hopi Reservation Day School while studying art with his father. In 1959 he entered Haskell Institute in Lawrence, Kansas, and was graduated in 1961. For a short time he attended the College of Engineering at the University of Arizona but withdrew from school in order to devote his full time to painting.

Lomawywesa had his first one-man show at the Heard Museum in Arizona in 1966. He has won many awards, including citations at the Gallup Inter-Tribal Ceremonial Competition, the Philbrook Art Center Art Competition in Tulsa, and the art exhibitions of the Museum of Northern Arizona, Flagstaff, and the Heard Museum.

Lomawywesa is a member of the Snow-Water Clan, which co-sponsors the annual Flute Ceremony held in Shungopovi on odd-numbered years (the Snake Ceremony is held on the even-numbered years). In 1967 Lomawywesa was initiated into the Wuwuchim, the Hopi Men's Society.

In 1970 Lomawywesa was elected president of the Hopi Arts

Lomawywesa: *"Hopi Elements,"* 1973; acrylics on canvas; 29 × 34 in.; courtesy
of Cochise College, Douglas, Arizona; photograph courtesy Patricia Janis Broder.

and Crafts Cooperative Guild, which was founded by his father in
1949. The artist is the subject of an extended discussion in *Hopi
Painting* by Patricia Janis Broder, who provided biographical data
and photographs of Lomawywesa's works for this book.

"The arts have always been an integral part of my life. It is
through the arts that I capture and share the values of my people's
spirituality, agonies, contradictions and happiness, and through the
arts that I clarify my fears, passions, joys; my birth and death."

Lomawywesa: *"Futurist Hopi," 1975; acrylics on canvas; 40 × 40 in; courtesy of the Hopi Cooperative Arts and Crafts Guild, Second Mesa, Arizona; photograph courtesy of Patricia Janis Broder.*

Lomawywesa: *"Kachina Lovers," 1974; collage; 27 × 26 in.; courtesy of the Hopi Cooperative Arts and Crafts Guild, Second Mesa, Arizona; photograph courtesy of Patricia Janis Broder.*

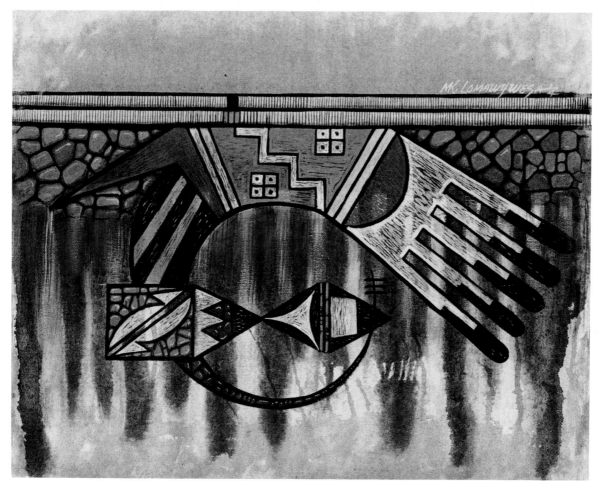

Lomawywesa: *"Turquoise Bird," 1974; acrylics on canvas; 16 × 20 in.; courtesy of the Hopi Cooperative Arts and Crafts Guild, Second Mesa, Arizona; photograph courtesy of Patricia Janis Broder.*

The Iroquois Indian George C. Longfish was born of
Seneca/Tuscarora parents in 1942 in Oshweken, Ontario, Canada.
He received his B.F.A. degree in 1970 and his M.F.A. degree in 1972,
both from the Art Institute of Chicago. He is currently an assistant
professor at the University of California at Davis.

"Since my training was not oriented toward Native art such as
the Institute of American Indian Arts or the Southwest area in
general, I have approached my painting and drawing in an abstract
sense that was in tune with concepts that are either European or
American. This is not to say that I didn't do the Indian image.
Looking at the work and studying the history of contemporary
Indian art, my attitudes changed. In many ways the Indian art of the
Southwest has always felt forced to me, and the concept of what it
should be has been dominated by both its creators and patrons. I
have looked back farther into the history of Native Americans to
their art when it was called artifacts, and begun to study these
forms, which I feel were more honest to the feelings of the Indians
that produced them. They were truly artists. Being in this time and
place, it's hard to combine the Indian abstract symbols with modern
concepts of painting, but it is beginning to happen."

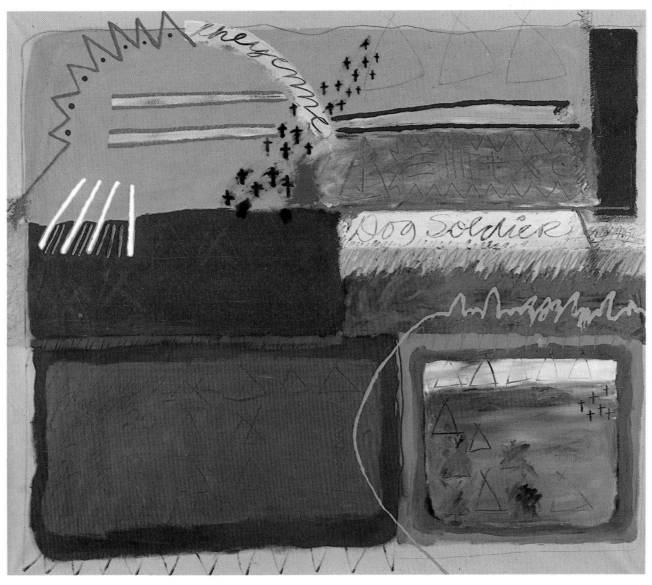

George C. Longfish: *"Cheyenne Dog Soldier,"* 1977; acrylics and graphite on canvas; 84 × 96 in.; courtesy of the artist.

DONALD MONTILEAUX

Donald Montileaux is an Oglala Sioux, born in 1948 on the Pine Ridge Indian Reservation in South Dakota. His father was his first art teacher, giving his son informal instruction in drawing cartoon animals. It was in high school in Rapid City, South Dakota, that Montileaux had his first opportunity to take an art course. Then in 1964 and 1965 he attended workshops held at the University of South Dakota in Vermillion. These courses, sponsored by the Sioux Indian Museum, were taught by Oscar Howe, the famed Sioux painter. Following his training under Dr. Howe, Montileaux entered the Institute of American Indian Arts in 1966. He received further instruction in art at Black Hills State College in Spearfish, South Dakota.

Montileaux now lives in Rapid City, South Dakota. His work has been shown at the Heard Museum, the Red Cloud Art Show in North Dakota, and the Sioux Indian Museum and is included in the traveling exhibition Contemporary Sioux Painting, organized by the Indian Arts and Crafts Board's Sioux Indian Museum and Crafts Center.

"Using my Sioux background as motivation, and using the symbols and designs which were applied to costumes, tipi liners, and

Donald Montileaux: *"Horse Spirit," 1977; acrylics on canvas; 24 × 36 in.; courtesy of the artist.*

shields through the use of beadwork, quillwork, and featherwork, I then transform the designs and symbols through my own ideas. Expressed in contemporary media, the final product becomes an insight in future viewings of my interpretations of my native heritage, of which I am proud."

GEORGE MORRISON

George Morrison is a member of the Grand Portage Indian Reservation in Minnesota. He was born in 1919 in Chippewa City, outside of Grand Marais, Minnesota. After traditional training at the Minneapolis School of Art (now the Minneapolis College of Art and Design) in the late 1930s and early 1940s, he went to New York, where he attended the Art Students League for several years. He was one of the first Native American artists to come up against the art scene of Manhattan. These educational experiences helped Morrison evolve the most highly individualistic style which had ever made itself known among Native American artists. Clearly what Morrison achieved by the end of the 1950s was a strong personal variation on the then-dominant Abstract Expressionist style. In his first mature works, figurative and landscape elements are embedded in complex linear patterns. It is a style that has won for Morrison the reputation of being one of the top three or four Indian painters, an artist whose work has powerful sensuality and delicacy.

Returning to Minneapolis in 1969, Morrison continued to make complex and fragmented surfaces, some tending toward loose cubist grids, others toward romantic landscapes in the Abstract Expressionist tradition. From paintings and graphics he recently turned to wooden pieces. He is now Professor of Studio Arts at the

University of Minnesota. He has had numerous shows, of which his regular exhibits at the Grand Central Modern Gallery in New York are the most persistent. His work is in numerous public collections, including the Whitney Museum of American Art (New York), the Philadelphia Museum of Art, the Virginia Museum of Fine Art (Richmond), the Art Institute of Chicago, the Minneapolis Institute of Art, the Walker Art Center (Minneapolis), the Heard Museum (Phoenix), as well as the Porr Museum in Germany and the Bezalel National Art Museum in Jerusalem.

George Morrison: *"Landscape: Wood Collage," 1973; wood; 60 × 168 in.; courtesy of the Minneapolis Institute of Art and the artist.*

"I am a painter but in recent years I have been working with found and prepared wood as well as with new wood. It is an extension of painting for me; with oil painting I was concerned with the textural surface, building up a thick impasto with layers of pigment.

"In the large-scale wood assemblages and collages I draw upon the evocative power of weathered and textured wood that also carries with it a sense of history. The organic nature of the material lends itself indirectly to earth, water, and sky. Although the general effect of the work is abstract, I make a deliberate attempt to suggest the

George Morrison: *"Untitled," 1972; black ink on Strathmore paper; 23 × 23 in.; courtesy of the Walker Art Center, Minneapolis, and the artist.*

broad expanse of landscape by using organic and structural forms and by showing a horizon line one quarter from the top.

"Most of the wood for the 'found material' pieces is from ocean beaches, but I also use local wood. Some is 're-weathered' and 'prepared.' These are assembled in mosaic fashion and glued to a sturdy plywood backing. The new wood pieces are more formal. In the large outdoor cedar mural at the Minneapolis Regional Native American Center, the motif was taken from a Chippewa feather design but the general effect is geometric and abstract.

"I have also begun to experiment with sculptural forms,

specifically my own interpretation of the totem idea—not telling a story through animal and human images but making an abstract version of structural and organic vertical form. There might be a remote suggestion of Aztec art in the way the forms are architecturally stepped up, but that was not intentional. The redwood is stained earth-red to give potency to the Indian feeling. I am also trying to gain a majestic quality of the totem with scale.

"A poet friend of mine remarked that there was an Olmec feeling to the 'Red Totem I' piece. I had certainly not thought of that but I felt good about the fact that perhaps 500 years later there was a reincarnation of a sculptural and architectural idea—by way of a Haida carver."

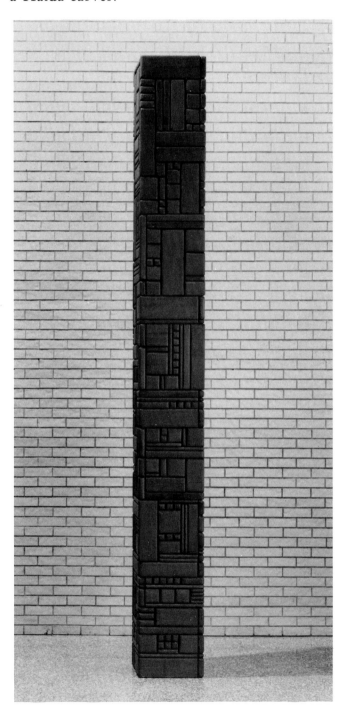

George Morrison: *"Red Totem I," 1977; wood; 15 × 15 × 144 in.; courtesy of the Art Institute of Chicago and the artist.*

George Morrison: *"Landscape: Wood Collage,"* 1972; wood; 48 × 120 in.; *courtesy of the artist.*

George Morrison: *"Landscape: Wood Collage,"* 1977; wood; 48 × 120 in.; *courtesy of the Hennepin County Medical Center and the artist.*

The artist most often credited with founding the "school" of Algonquin Legend Painters in Northern Ontario is Norval Morrisseau, an Ojibwa from the Sand Point Reserve on Lake Nipigon in Ontario, Canada. Born in 1933, he did not begin painting until about 1959, after he experienced a revelation instructing him to be an artist. His first paintings were done on birch bark because that was the only material he could obtain. In 1960 his paintings came to the attention of art dealer Jack Pollock, who took thirty-six of his works back to Toronto, where all of them sold in a day. Morrisseau's renown has gradually spread, and today he is considered one of Canada's principal Native painters.

Morrisseau is profoundly motivated and feels strongly that he has been chosen to set down the heritage of the Ojibwa and to perpetuate the traditions and life-force of his people before they disappear. Morrisseau's life-style is highly rebellious and antisocial from the viewpoint of some of his conservative critics. He defied tribal prohibitions against depicting events and characters from the legends of his people, and this caused enormous opposition from tribal elders. As Bernard Cinader, an expert on the subject, wrote, "The first attempts of Morrisseau to paint the sacred legends of his people were fiercely resisted by those who guarded the secrets of the

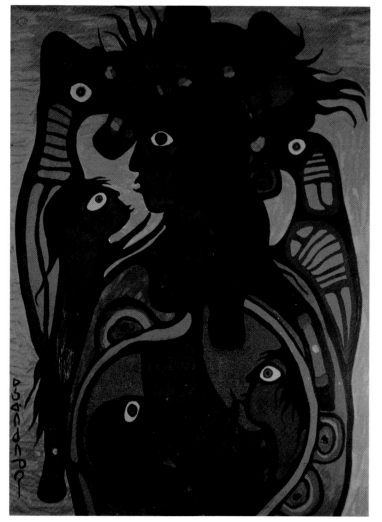

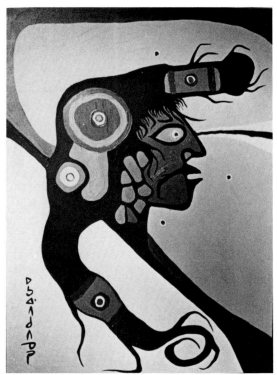

Norval Morrisseau: *"Children, Mother and Lion,"* 1972; acrylics on paper; 29 1/2 × 40 in.; courtesy of the Bernhard Cinader Collection, Toronto (left); *"Spiritual Self,"* 1977; acrylics on canvas; 38 × 47 in.; courtesy of H. Band, Toronto (right).

Midewiwin society, but Morrisseau persisted, and as he developed his own capacity as a painter, the opposition to his work gradually declined."

From this rebelliousness came a totally invented idiom of Indian art that is almost entirely without debt to the techniques or media of Algonquin (Ojibwa, Odawa, and Cree) pictorial traditions. The figuration of Morrisseau's paintings possesses a tentacled lineation recalling the antennas that twine out of the shapes depicted in the tapas of New Guinea. Except for its controversial legendary subject matter, Morrisseau's art has little relationship to what we normally call Traditional North American Indian painting. In short, the Legend art of Norval Morrisseau represents a vital step in Indian individualism. As the art historian John Anson Warner has indicated, "Morrisseau's paintings are spontaneous, colorful, imaginative, and entirely original. As a seminal force Morrisseau has not been content to stand still artistically." With the dawning of the 1970s he began to turn more and more to mystical paintings which were infused with both the legends of his grandfathers and the early Roman Catholic teachings of his youth. As time has gone on his art has become more personal and even autobiographical. As a person he has lived a

Norval Morrisseau: *"Ojibwa Headdress";* silk screen; 36 × 48 in.; courtesy of John Anson Warner, Regina.

Norval Morrisseau: *"Woman Suckling Bear,"* 1970; acrylics on paper; 22 × 29 in.; courtesy of the Bernhard Cinader Collection, Toronto.

confused, chaotic, and often trouble-ridden existence. Artistic success has had little effect on Morrisseau's nomadic life. He lives as a wanderer, often sleeping in the grass, vacant boxcars, or abandoned automobiles. Morrisseau is unconcerned with public opinion. "If man can't accept me the way I am, to hell with him," he has said.

Morrisseau's individualism and artistic achievement have spawned a whole "school" of assertive artists, collectively called the Algonquin Legend Painters. The most important among these painters who came after Morrisseau are Carl Ray, the brothers Goyce and Joshim Kakegamic, and Jackson Beardy. Another artist of importance in Canada is Daphne Odjig, whose work, though possessing some debt to Morrisseau, is essentially the product of European mannerism. More directly related to Morrisseau's Algonquin Legend art are young men such as Samuel Ash, a gifted young Ojibwa painter, and the extraordinary James Simon.

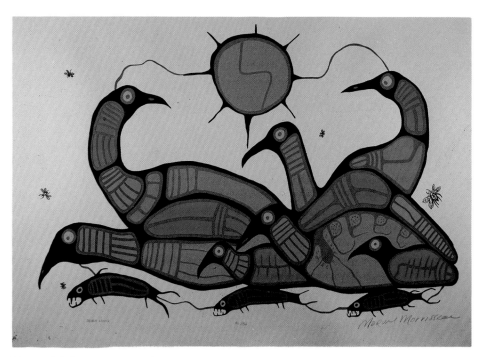

Norval Morrisseau: *"Seven Loons"; silk screen; 36 × 48 in.; courtesy of John Anson Warner, Regina.*

Norval Morrisseau: *"Migration," 1973; acrylics on canvas; 50 × 36 1/2 in.; courtesy of the Bernhard Cinader Collection, Toronto.*

Dan Namingha was born in 1950 on the Hopi Indian Reservation in
Arizona. A member of the Tewa tribe, he now makes his home at
San Juan Pueblo, but he grew up on Second Mesa among the Hopi,
where his Tewa people had migrated many years ago. He is a
descendent of the famous potter Rachel Nampeyo, who was largely
responsible for the revival of classical Puebloan pottery, ca. 1900.
After his early schooling at Keams Canyon, he sought a wide variety
of training and experiences, which he discovered at the University of
Kansas, the Institute of American Indian Arts, and the American
Academy of Art in Chicago. His worldliness was also enhanced
while touring as a musician and while serving in the Marine Corps,
1970–72.

Namingha's works are in the collections of the Museum of
Northern Arizona and the Heard Museum, and his paintings have
been exhibited by the Philbrook Art Center (Tulsa), the California
Academy of Sciences, the Museum of the Institute of American
Indian Arts, the Scottsdale National Indian Arts Exhibition, and the
Museum of Albuquerque.

"Schooling didn't help me as much as my own experimenting.
Experimentation helps create an artist's unique style. I just do

Dan Namingha: *"Niman Kachina," 1978; acrylics on canvas; 68 × 58 in.;*
courtesy of The Gallery Wall, Phoenix.

whatever comes out of me, out of my mind. What I feel, not any
particular style. If I would get stuck with one style, I don't know
how I'd get out of it. To be able to do whatever you want is the
freedom of being an artist. I remember walking to Walpi on First
Mesa with my grandfather to see the dances on moonlit nights. I
helped him with the stuff he had to carry. My grandfather would go
from one *kiva* to another the whole night. We would carry

gunnysacks full of goodies to give to the people in the *kiva*. It was mysterious, in a way. There was so much to see and I saw things differently, things others may have taken for granted. To stand there and look at the place, the background, very peaceful yet strong, exciting—that's what I've strived to capture. I don't paint about forbidden things. I do something else . . . taking it all in and using it, not to hurt or to exploit, but to express."

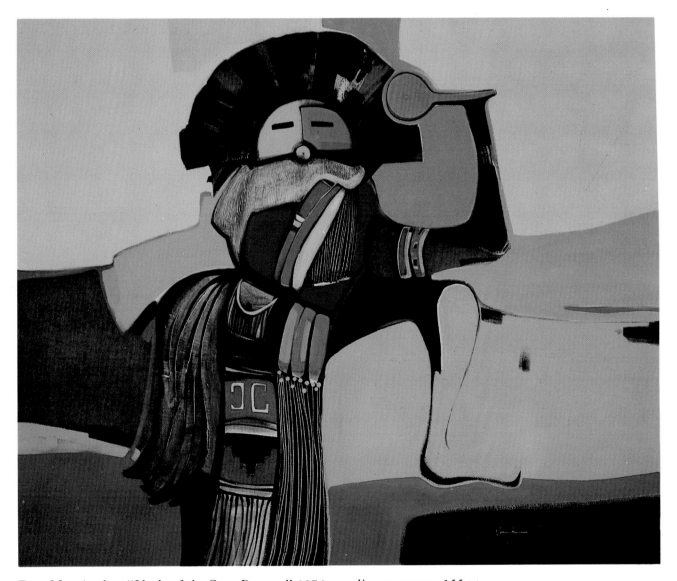

Dan Namingha: *"Uncle of the Corn Dancer," 1976; acrylics on canvas; 155 × 67 in.; courtesy of The Gallery Wall, Phoenix.*

MICHAEL NARANJO

Michael Naranjo was born in 1944, a Tewa Indian of the Santa Clara Pueblo, raised both there and in nearby Taos, New Mexico. He had always aspired to be an artist and at an early age began modeling in clay and making sketches. In 1968, when the twenty-four-year-old artrist lost his sight, his artistic activity began to flourish rather than diminish. Visions and tribal dreams appeared in his work with a new intensity that demanded tactile forms, and in a very few years Naranjo produced a substantial body of work. By 1970 he began to cast in bronze and was exhibiting his work nationally in both group and one-man shows.

Naranjo's sculptures are highly diversified in subject matter, including pieces commemorating Indian heritage and works that reflect the unique environment of New Mexico, where he still makes his home.

"Art is something to be appreciated on a very personal level; it is to be enjoyed while it's happening and exists to give pleasure to those viewing it. When you see someone's work that excites you, it touches you inside—it might make you happy or make you sad, but whatever feeling it happens to evoke, it is a very emotional experience for both the artist and his audience. When I myself am

working, there seems to be an intensely emotional cycle I go through. First, frustration when I can't find what I'm looking for . . . then relief as I begin to see the idea coming. While I am working, while the piece is happening, it can only be described as ecstasy, followed by pleasure and satisfaction upon its completion. And lastly, a tinge of momentary sadness runs through me as the experience is ended and I wait for the cycle to begin again."

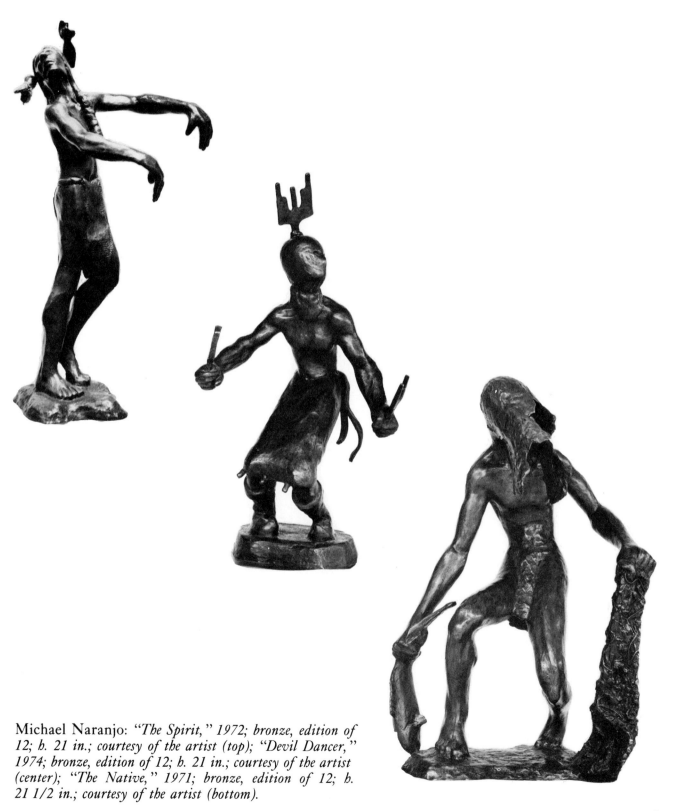

Michael Naranjo: *"The Spirit,"* 1972; bronze, edition of 12; h. 21 in.; courtesy of the artist (top); *"Devil Dancer,"* 1974; bronze, edition of 12; h. 21 in.; courtesy of the artist (center); *"The Native,"* 1971; bronze, edition of 12; h. 21 1/2 in.; courtesy of the artist (bottom).

NEIL PARSONS

Neil Parsons, a member of the Blackfeet tribe, was born in 1938 in Browning, Montana. He attended schools there and also studied art at Montana State University, Bozeman. For his master's thesis in the arts he produced a monumental four-part abstract composition in oils and masonite. Based on themes drawn from the Plains Indian cultural past, this work was created by Parsons for the Indian Arts and Crafts Board's Museum of the Plains Indian in Browning.

Parsons has taught art in Browning and at the Institute of American Indian Arts in Santa Fe, at Western State College of Colorado in Gunnison, and the University of Montana, Missoula. Currently he holds the position of Indian cultural coordinator for the Montana Arts Council, working on a program supported by a matching grant from the National Endowment for the Arts. He also serves on the Visual Arts Advisory Panel for the Montana Arts Council, in reviewing grant proposals in that area.

Parsons's work has been exhibited at the Seattle Art Museum, the Denver Art Museum, the University of Washington Gallery, the Montana Institute of the Arts, the Museum of the Northern Plains Indian, and the Museum of the American Indian in New York, as well as in festival exhibitions at Edinburgh and Berlin.

"The language of vision is one having few barriers—how one shape of color relates to another continues to be a universally accepted challenge, regardless of time or place. In so doing, I am greatly inspired by the traditional decorative elements of my ancestors. The idea of abstract Indian painting took form as a result of a change in attitude. Earlier, it had seemed that in order to succeed in painting it would be necessary for me to overcome the compulsions of my Indian background, and try to lose my identity with that tradition in the overwhelming atmosphere of a big, modern city. However, I gradually realized that the forces of a motivating atmosphere like the city and those of an individual's background are two different things, and that I might best be able to express myself through the use of traditional Indian cultural ideas in an intellectualized contemporary manner."

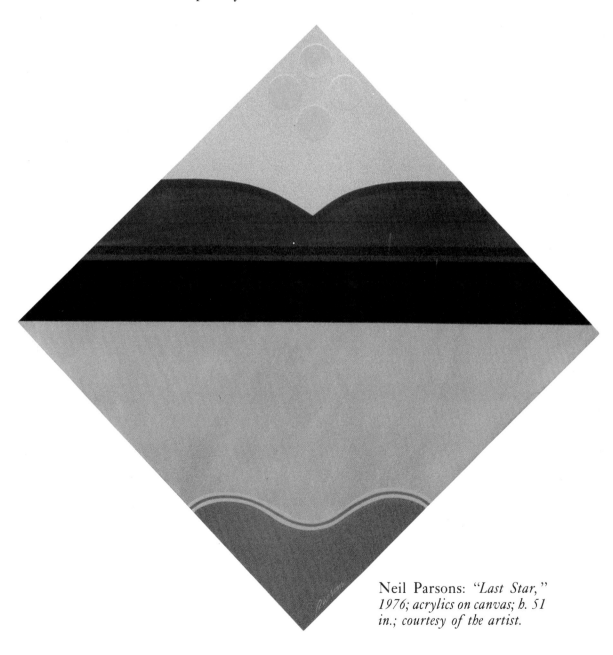

Neil Parsons: *"Last Star,"*
1976; acrylics on canvas; h. 51
in.; courtesy of the artist.

The most influential of the Algonquin Legend Painters after Norval Morrisseau was Carl Ray, a Woodland Cree Indian who was born in 1943 on the Sandy Lake Reserve in northwestern Ontario. John Anson Warner wrote of him that he was "seeking to recapture for posterity the legends and culture of his past before 'all is lost in the void of the white man's civilization.' " Ray used his self-taught art technique to depict the sacred stories told to him by his grandfather, one of the most awesome holy men among the Cree of Sandy Lake. Ray had a dramatic manner, but the most impressive of all his works were the pieces executed with pen and ink.

Carl Ray died early in 1979 in a brawl.

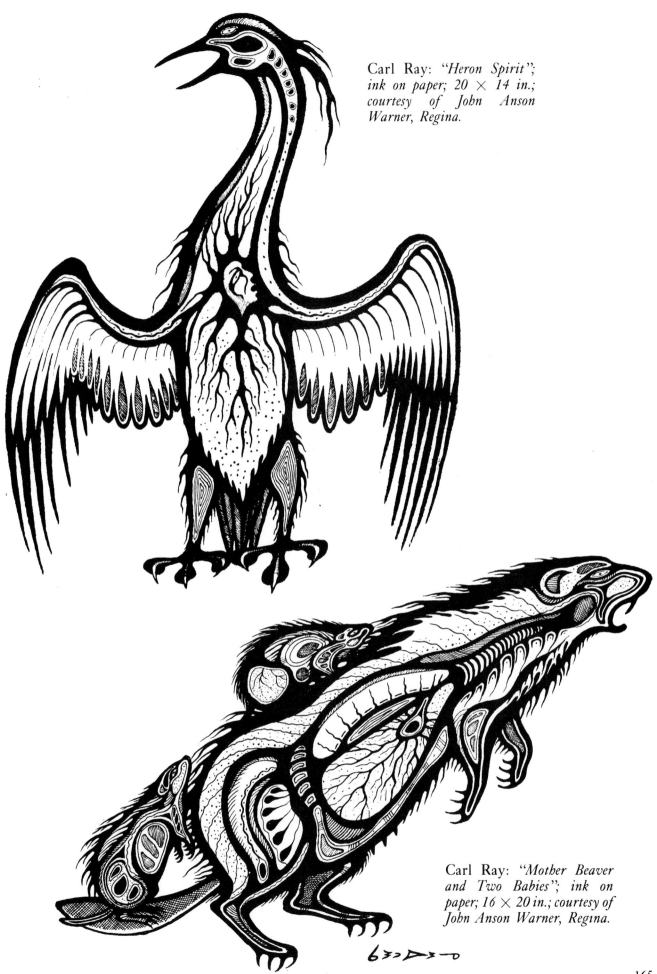

Carl Ray: *"Heron Spirit"*; *ink on paper; 20 × 14 in.; courtesy of John Anson Warner, Regina.*

Carl Ray: *"Mother Beaver and Two Babies"*; *ink on paper; 16 × 20 in.; courtesy of John Anson Warner, Regina.*

RICHARD RAY (WHITMAN)

Richard Ray (Whitman) was born in 1949 at the Claremore Indian Hospital in Claremore, Oklahoma, of Yuchi-Pawnee heritage. He grew up speaking the Yuchi language in Bristow, Oklahoma, in the home of his grandmother, Polly Long, who had a deep impact on his Indian sensibility.

His training after high school was completed at the Institute of American Indian Arts (Santa Fe), the California Institute of Arts (Valencia), and the Oklahoma School of Photography (Oklahoma City).

Currently he is an assistant exhibits technician at the Oklahoma Historical Society in Oklahoma City, and in his free time is compiling a book of writings, poetry, and photographs of "street" Indians. Whitman is strongly political in mentality, having proudly served as "Artist in the People's Struggle" in retaining tribal identities and reverence for the natural world at Wounded Knee, South Dakota, in 1973. He has also been active in the Poetry and Visual Presentations program of the Oklahoma State and Federal Penal System.

In 1974 he was artist-in-residence for the Oklahoma Arts and Humanities Council and in 1974–75 he was the art instructor at the Native American Center in Oklahoma City.

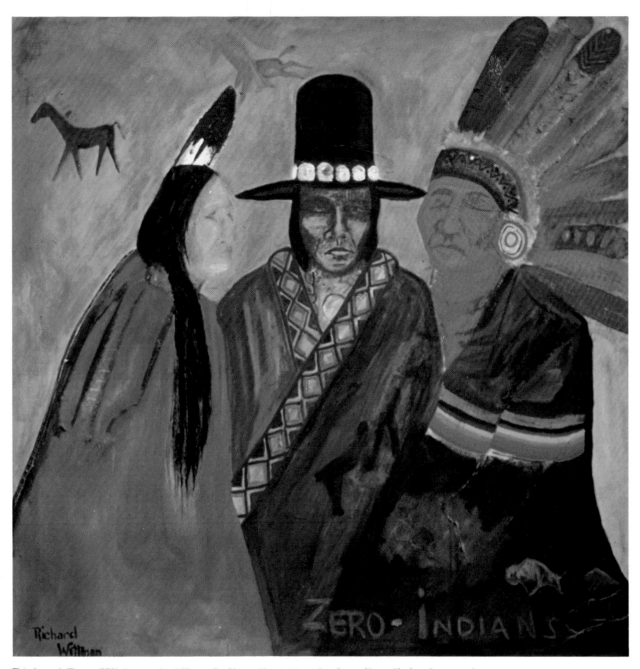

Richard Ray (Whitman): *"Zero-Indians," 1969; mixed media; oil, leather, and horsehair; 48 × 60 in.; courtesy of the Museum of the Institute of American Indian Arts, Santa Fe.*

Kevin Red Star was born in 1943 on the Crow Indian Reservation in Lodge Grass, Montana. He is one of nine children of Wallace and Amy Red Star. In 1962–65 he attended the Institute of American Indian Arts in Santa Fe and then received a two-year scholarship from the San Francisco Art Institute. He also attended Montana State University in Bozeman and Eastern Montana College in Billings.

Since 1965 Red Star has shown in over fifty shows throughout the United States and has also been exhibited in Scotland, Germany, England, and Turkey. His paintings are among the most popular of a large following of collectors. His awards include the Heard Museum's Honorable Mention in 1964 and First Prize and Governor's Choice at the 1965 Scottsdale National Indian Art Exhibition. Most recently Red Star was one of a group of Indian artists featured in the Pierre Cardin exhibit in Paris in 1979.

Today Kevin Red Star makes his home in Santa Fe. Among the several galleries regularly exhibiting his works are the Carol Thornton Gallery in Santa Fe and the Hukahee Fine Arts Gallery in Scottsdale.

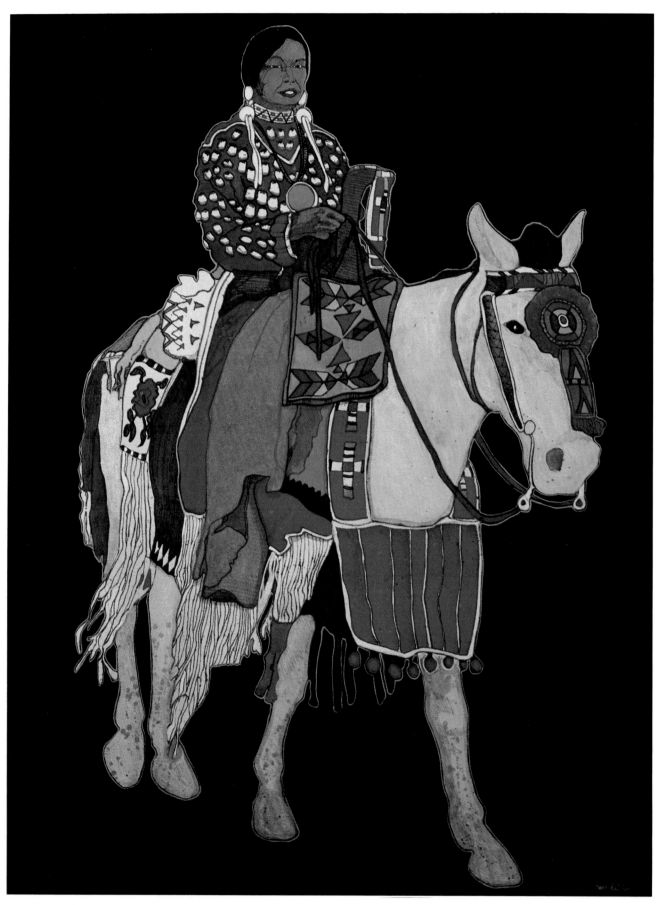

Kevin Red Star: *"Crow Fair, 1978,"* acrylics on canvas; 42 × 32 in.; courtesy of the Carol Thornton Gallery, Santa Fe.

The Cree Indian painter Allen Sapp was born in 1929 on the Red Pheasant Reserve some thirty miles south of the town of North Battleford, Saskatchewan, Canada. His mother died shortly after his birth, and he was brought up by his grandmother, Mrs. Maggie Soonias. As John Anson Warner, the expert on Sapp, has indicated, "Sapp came to revere and love his grandmother very much. So much so, in fact, that Maggie Soonias constantly appears and reappears in his paintings."

At the Onion Lake Residential School, Sapp was not a particularly good pupil, preferring to draw rather than to study. As a result, today he is a timid man who speaks very little English and cannot read or write. Warner quotes Sapp as saying, "I can't write a story or tell one in the white man's language, so I tell what I want to say with my painting."

Sapp's life has been far from easy. Ill health has hounded him since childhood. In 1955 he married Margaret Paskimin Whiteford from the nearby Sweetgrass Reserve. Sapp had difficulty earning a living for his wife, his son David, and himself. There was no possible source of income on the reserve, so Sapp moved to North Battleford, where he found himself completely at odds with the urban environment. He was soon on line for welfare. The only

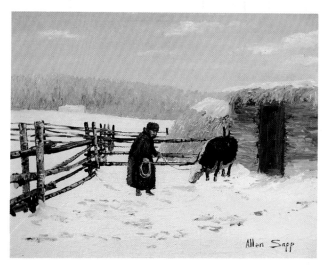

Allen Sapp: *"Time to Milk the Cow,"*
1977; acrylics on canvas; 16 × 20 in.; cour-
tesy of John Anson Warner; photography by
M. René Wassill.

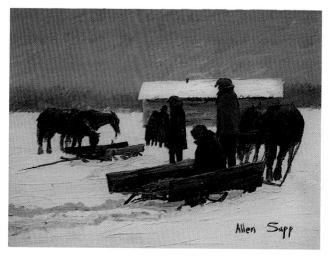

Allen Sapp: *"People Getting Together on*
Stoney Reserve," 1974; acrylics on canvas;
12 × 16 in.; courtesy of John Anson
Warner; photography by M. René Wassill.

employment he could find was part-time work at a local hobby shop whose generous proprietor, Mrs. Eileen Barryman, gave him a few lessons in painting. Almost at once Sapp began selling his first efforts for trifling sums.

Then in 1966 Sapp met Dr. Allan B. Gonor, a prominent North Battleford physician. Dr. Gonor was impressed by Sapp's talents and became his mentor, arranging for Sapp to have some tutoring from the painter Winona Mulcaster, who teaches art at the University of Saskatchewan in Saskatoon. Eventually Dr. Gonor and Sapp formed a partnership, which resulted in the first exhibition of the artist's works in Montreal.

Allen Sapp's work is closely related to European genre painting, though he is probably unaware of this influence. Sapp simply paints the real life of the Cree people who lived on the Saskatchewan reserves in the 1930s and 1940s. He is probably the first Indian artist in his region to evolve a realist's eye and to attempt consciously to depict his people the way they really were during the period of his boyhood.

Sapp and other Indian artists devoted to genre painting (Gawboy, Standing Soldier, Broken Rope) have devised a style quite distinct from the idioms derived from Traditional Indian art. Sapp has a wholly Indian vision—his subjects are clearly and strongly

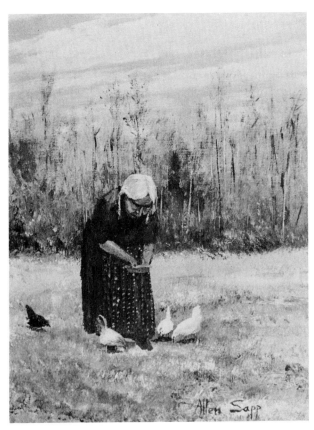

Allen Sapp: *"Springtime at Red Pheasant Reserve,"* 1972; acrylics on canvas; 24 × 18 in.; courtesy of Dr. Allan B. Gonor and W. H. Baker in behalf of the artist.

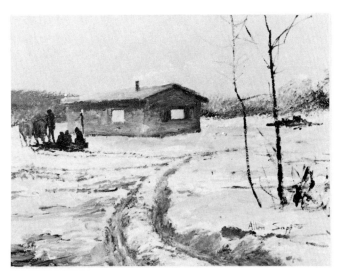

Allen Sapp: *"Christmas Evening, Red Pheasant Reserve,"* 1972; acrylics on canvas; 18 × 24 in.; courtesy of Dr. Allan B. Gonor and W. H. Baker in behalf of the artist.

nostalgic—but his technique and manner derive solely from European oil painting of the late nineteenth century. In luminosity, ambiguity of realistic detail, and surface quality, Sapp's paintings are a blend of styles reminiscent of Alfred Sisley ("Snow at Louveciennes," 1874) in particular, but also Pierre Bonnard ("Woman and Child," 1899) and Edouard Vuillard ("Landscape at l'Etang-la-Ville," 1900). Though the traditions of such painters, and even their works in reproduction, may have directly influenced Sapp, it is far more likely that his manner is the result of his own vision of the world and the mixture of graphic traditions of the world in which he grew up.

On November 25, 1975, Sapp received the great honor of election to membership in the Royal Canadian Academy of Arts (RCAA) in recognition of his outstanding achievements in the visual arts field. In 1976 he was given a one-man show at the Hammer Galleries in New York. The struggle for existence is finished for him, but the vision of the world of his childhood persists in his delicate, illuminated evocations of the 1930 world of Grandmother Maggie Soonias.

Allen Sapp's life and work is the subject of an extended

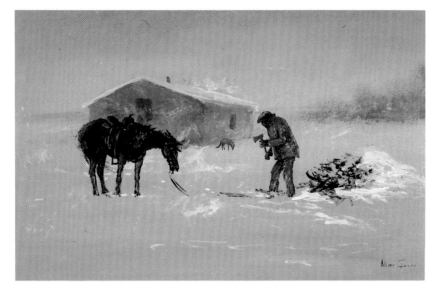

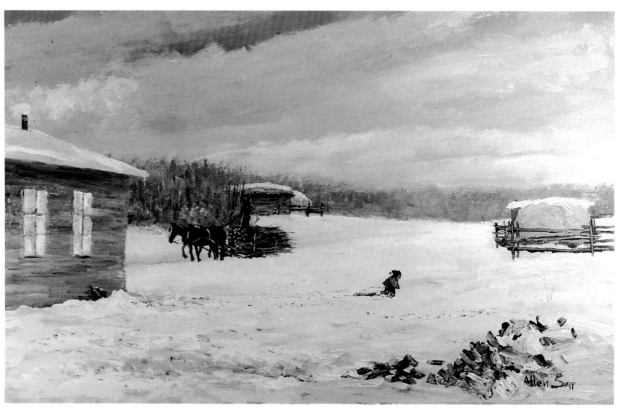

Allen Sapp: *"Blowing Snow," ca. 1972; acrylics on canvas; 24 × 36 in.; courtesy of the Allan B. Gonor Collection and John Anson Warner, Regina (top); "My Old Place a Long Time Ago," ca. 1969; acrylics on canvas; 30 × 48 in.; courtesy of the Allan B. Gonor Collection and John Anson Warner, Regina (bottom).*

discussion in several articles as well as in the book *A Cree Life: The Art of Allen Sapp* by John Anson Warner, who provided biographical data, photographs, and unlimited assistance in presenting Sapp's works in this book.

"When I was little boy I went out sometimes with my grandfather Wuttunee to get a load of wood. In the bush we cut the wood, we loaded it up on a sleigh, and brought that sleigh back home. Before I was artist full-time I used to cut wood and sell it in Cando to get money, or trade the wood for food for me and my family. Those were hard times, not like today."

Fritz Scholder was born in 1937 in Breckenridge, Minnesota, son of a part Mission (Luiseño) Indian father and non-Indian mother, Ella Mae Haney. He is probably the single most accomplished and internationally successful contemporary Indian painter. His French-English-Indian-German background, his various changes of residence and educational systems during his years of growing, and his current exhibitions across the United States and Canada and in many other nations provide every art enthusiast with some area of identification with Scholder and his work.

Scholder's early schooling was in South Dakota and Wisconsin. In 1957 he arrived in California, where he received his B.A. degree from what was then Sacramento State College. Invited to participate in the Rockefeller Foundation-sponsored Southwest Indian Arts Project at the University of Arizona in Tucson, he left his substantial day job as a substitute teacher in Sacramento and his night job for the California State Department of Motor Vehicles to attend the project. For one year he was a student, but he became part of the faculty in his second year. It was at the University of Arizona that Scholder received his M.F.A. and won his first recognition with a series of important awards. It was not until 1964, however, while teaching at the Institute of American Indian Arts in

Santa Fe, that he turned from painting stripes and nudes to painting Indian subject matter. He was greatly encouraged by Oscar Howe, the Sioux painter who, probably more than any other Indian artist, has made the transition from Traditional to Contemporary Indian art. Another early influence was the Pop artist Wayne Thiebaud, whom Scholder met at the San Francisco Art Institute. But the greatest impact on his highly original style is clearly the English painter Francis Bacon. What Scholder did, which was quite astonishing, was to portray the Indian in a dramatic and strongly expressionist manner, never previously used with this colorful, folkloric Western subject.

His work was immediately damned by Traditional Indian painters, who perhaps misunderstood Scholder's work, considering it an insult to custom and Indian dignity rather than a highly ironic expression of the Indian as the metaphoric underdog. There were even demonstrations outside galleries where Scholder's paintings were on exhibit by young traditionalists who felt that the art defiled the Indian image. Though the Canadian Indian artist Norval Morrisseau was confronted by much the same fierce opposition, it was Fritz Scholder who was the *first* really controversial Indian individualist painter. Scholder was also the most visible and successful, and the denunciations of his work very nearly became a cliché in the Indian world. But his daring and his brilliance as a colorist, his irony and its subtle militancy attracted the attention of

Fritz Scholder: *"Indian With One Eye,"* 1975; *acrylics on canvas; 80 × 68 in. courtesy of the artist.*

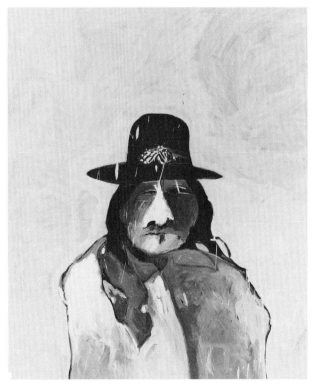

Fritz Scholder: *"American Portrait with Dead Butterfly,"* 1975; *acrylics on canvas; 80 × 68 in.; courtesy of the artist.*

young Indian painters across Canada and the United States. A whole generation of Indian artists have been strongly influenced by Scholder.

Today Fritz Scholder lives in Galisteo, New Mexico, in the summer and in Scottsdale, Arizona, in the winter. He has had exhibitions of his paintings and lithographs in most major Canadian and American cities, as well as in Berlin, Bucharest, London, Belgrade, Madrid, Warsaw, Paris, Rome, Athens, and Ankara. He is a man of great personal style and worldliness, but at the same time his attitude is completely unpretentious and candid.

"Working from a unique perspective as a non-Indian Indian, I can only continue my individual odyssey. In the sixties, when I introduced subjects into my paintings like the 'Indian with Beer Can,' Indians wrapped in American flags, and the monster Indians, combined with my non-Indian background of Abstract Expressionism and Pop art, many so-called experts were threatened and the work became 'controversial.' I was surprised at the reaction,

Fritz Scholder: *"Reservation Dog,"* 1978; oil on canvas; 68 × 80 in.; courtesy of the artist.

for all that I was trying to do was to approach a loaded subject—the American Indian—in real terms. In reacting against the romantic clichés of the old Taos School of painters, I found that the *real* subject was even more dramatic than the false one. In a way, I am a paradox. I have changed the direction of so-called Indian painting, but I don't consider myself an Indian painter. I am often called an 'Indian artist' and I am on the official Government rolls, but still I am not simply an Indian painter. Although I am extremely proud of being one quarter Luiseño Indian from Southern California, one cannot be any more or less than what he is. At any rate, the future of 'Indian Art' depends on the 'Indian Artist.' If the path of least resistance is taken and he continues to paint only traditional Indian subjects, the movement will stagnate. The magenta Indian chasing the last buffalo over the cerulean blue hills is pretty boring by now. The American Indian artist, like everyone else, lives in 1979 or 1980 and must cope with that fact in his work. An Indian artist must have the freedom to do anything he wants . . . like every other artist. To be strong, the work must come from a strong individual identity and then transcend all boundaries. If an artist is a full-blood Indian the work will be full-blood Indian and no one needs to worry about whether 'Indian Art' is coming to an end." (Fritz Scholder, courtesy *The Indian Trader.*)

Fritz Scholder: *"On the Road to Taos,"1978; oil on canvas; 16 × 20 in,; courtesy of the artist.*

Fritz Scholder: *"Taos Meadow," 1978; oil on canvas; 16 × 20 in.; courtesy of the artist.*

JAUNE QUICK-TO-SEE SMITH

Jaune Quick-to-See Smith, who is of French-Cree and Shoshone descent, was born in Montana and is registered at the Confederated Salish and Kootenai Tribes of Flathead Lake. She also lived on the Hupa and Nisqually Reserves, having spent most of her childhood in the American Pacific Northwest. Daughter of a horse trader, she traveled from one Indian reservation to another. Her art strongly reflects that heritage. She fills maplike landscapes with the iconographic outline of tipis, water holes, hunters, and animal tracks. There is a strong influence in her work from cave paintings, rock art, and the Ledger style of the Plains tribes.

Smith's education included work at Olympic College in Bremerton, Washington, the University of Washington in Seattle, and Framingham State College, where she received her bachelor's degree in Art Education and was graduated magna cum laude. She was awarded her master's degree from the University of New Mexico in 1980. Her career as a painter has soared since 1979, when she was seen in a group show at the Droll/Kolbert Gallery and in a two-person show at the Kornblee Gallery, both in New York. A member of the group called the Grey Canyon Artists of Albuquerque and of the New Mexico Women in the Arts Association, Jaune Quick-to-See Smith is rapidly becoming one of

Jaune Quick-to-See Smith: *"Porcupine Ridge Series, No. 35," 1979; pastel; 30 × 40 in.; courtesy of the artist and the collection of Ms. Laurel Reuter, N.D.*

the most visible and important Native American painters. Among the several galleries which represent her work is the Clarke-Benton Gallery in Santa Fe, New Mexico.

"Gestural marks for the sweet grass build bars of contemporary grids. Also reminiscent of old ledger books. These make a modern framework for windows of narrative pictographs. Grids which are contemporary and pictographs which are ancient. A push and pull in time and space. Or as positive and negative as any woman's work in quills or beads. Men are narrative and women are abstract. And I incorporate both. These polarities make the work live in the present tense and with a touch of humor. I am the bridge-maker. Art and artists that are important to me are Oscar Howe, Paul Klee, Fritz Scholder, Robert Rauschenberg, Esteban Vicente, and Diebenkorn, as well as the media of petroglyphs, pictographs, old skin robes, cave painting, ledger art, and muslin painting."

Billy Soza War Soldier, a Cahuilla/Apache Indian, was born in 1949 in Santa Ana, California, and went to Hemet High School, also in California, for his freshman and sophomore years. He then traveled to Santa Fe for his junior and senior years, 1964–68, at the Institute of American Indian Arts, where he continued with graduate studies during 1969.

In 1970 Billy War Soldier was involved with Indian activism in such actions as the Plymouth Rock takeover by the American Indian Movement (AIM) and the Native American occupation of Alcatraz Island in San Francisco Bay, California. Political concern is foremost in Soza War Soldier's life. In 1971 he was considered a federal fugitive, facing various federal charges stemming from his militant activities. Between 1971 and 1977 he was involved in the takeover of the Bureau of Indian Affairs office in Washington, D.C., participated in the Trail of Broken Treaties demonstrations and the Mount Rushmore occupation, attended the National Convention of the American Indian Movement (AIM), and was also involved in the Wounded Knee demonstrations, as well as the political activism that took place at Black Mesa, Arizona, and at the PHS Hospital in Gallup, New Mexico. This political activity ended in a shoot-out with federal agents in New Mexico, and in 1973 Soza War Soldier

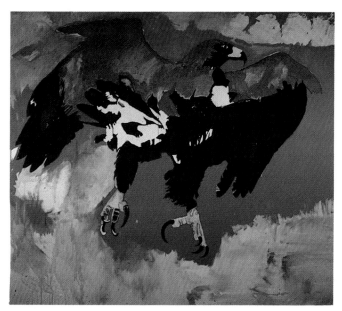

Billy Soza War Soldier: *"Death from Above,"*
1979; acrylics on canvas; 72 × 84 in.; courtesy of
the artist .

Billy Soza War Soldier: *"FBI Death," 1979;*
acrylics on canvas; 26 × 40 in.; courtesy of the
artist.

was arrested by the FBI in Albuquerque, New Mexico. Shortly after
his arrest, this talented painter managed to escape from the federal
officers and go underground as a fugitive. During the preparation of
Song from the Earth: American Indian Painting, in which this artist's
work appeared, he could contact the author only through friends.

In 1978 Soza War Soldier was again arrested by federal agents,
this time in Davis, California, and he subsequently served a total of
eleven months in various federal institutions.

"I had various exhibits of my work from 1966 to 1973, but I was
a federal fugitive at the time, so I couldn't attend. During the past
decade my radical political beliefs have not changed but have been
strengthened through outside experiences in the Indian
underground. Demonstrations, takeovers, occupations only lead to
bloody confrontations, arrests, beatings, murders; to be beyond this
law you must be wanted. . . . Through my art I say what is inside of
me and direct it at the U.S. Government and fear no reprisal because
it is my art."

JOHN J. WILNOTY (WILNOTA)

John Julius Wilnoty (or Wilnota), a highly regarded carver of the Eastern Band of the Cherokee, was born in 1940 in the Bigwitch community of the Qualla Indian Boundary, located in the mountains of western North Carolina, where the Cherokee were, in part, originally located before their tragic removal to Oklahoma. Wilnoty began carving during the early 1960s, working in a dark-hued pipestone, or steatite, found locally in North Carolina and long used by Indians for making vessels, pipes, and effigy figures. A residue of this sculptural tradition was alive in Wilnoty's Qualla culture as he grew up, and though he had no formal Western training in the purely academic sense of the term, he began to explore the techniques of carving pipe bowls along pre-Columbian lines. Eventually he mastered a technique he felt was derived from the prehistoric mound-building cultures of his region. His work both in wood and in stone quickly drew the attention of local collectors and merchants, whose patronage encouraged Wilnoty to experiment further and to broaden the basis of his unique art forms.

Concentrating on themes adapted from the folk history of the Eastern Cherokee, Wilnoty produced an impressive variety of works in a style similar to that of Iroquois sculptor Duffy Wilson, though the manner of both artists is clearly an independent creation.

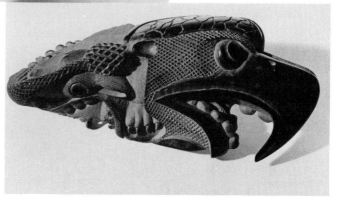

John J. Wilnoty: *"Saber-toothed Bull Bat,"* *1971 (three views); green-gray steatite, 6 × 3 × 1 in.; courtesy of the artist; photograph by Richard Gross; the Wilnoty works are from a private collection.*

Wilnoty's work has been exhibited widely, including major shows at the former Pasadena Art Museum (now the California Design Center). As Wilnoty's works have evolved he has consciously and perhaps unconsciously brought to it many influences from a variety of American tribes: Northwest Coastal forms, Maya relief styles, and even African sculptural elements.

"I carve because that is the talent God gave me, and I was lucky I found it. When I was twenty years old, there was no way to make a living for me and my family because I had these sleeping spells where I just passed out any old time. Pretty soon, after I did my praying about finding a way to make a living, I picked up some little pieces of pipe rock and carved faces on them. I took them to friends that sold crafts here in the town of Cherokee. They bought the little pieces and sold them real soon; wasn't too long I was making and selling a good many. I liked to do this. Then one day someone told

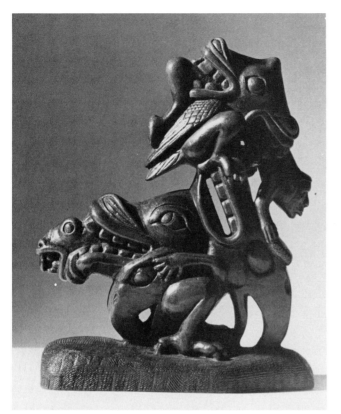

John J. Wilnoty: *"Dual-Headed Totem,"* 1970; red pipestone with brown stain; 6 3/4 × 8 × 3 in.; courtesy of the artist; photograph by Richard Gross.

John J. Wilnoty: *"Large Primitive Man,"* 1968; gray steatite; 5 × 4 × 4 in.; courtesy of the artist; photograph by Richard Gross.

me I ought to make some stone pipes like the old Cherokee pipe-makers. I went over to the Cherokee Museum and looked at what they had. I thought that I could make better pipes than the ones the museum had. So I did. They sold, and I kept making better ones; and they kept selling. But one thing I always tried to do and that was to make every piece different and better. I looked at books about carving of all kinds. I couldn't read about them because I can't read much. Nearly all the carvings I looked at I thought I could do better. I started carving men and animals, but I didn't copy anybody's—just got my ideas from looking at other pieces. They sold too. I started making my own tools more and learning how to use them. I never did study with nobody else—just myself. I learned to carve stone, then wood, then bone, and later I started fixing stone axes and pipes with leather. Hunting for the stone I work with takes me all over the mountains. I have a hard time finding good carving rock. Now I get good prices for my work. This is the talent God gave me."

ALFRED YOUNG MAN

The Cree Indian artist Alfred Young Man was born in 1948 in
Browning, Montana. After finishing boarding school on the Blackfeet
Indian Reservation, he attended high school at the Institute of
American Indian Arts in Santa Fe, where he earned a scholarship to
the Slade School of Fine Arts (University College of London), taking
a Diploma in Art and Design. Young Man later completed a master's
degree at the University of Montana and began his teaching career
as art instructor and reading specialist on the Rocky Boy Reservation
and later on the Blackfeet Reservation. In addition, he has worked as
a media specialist at Flathead Valley Community College in
Kalispell, Montana, and is presently Assistant Professor of Native
American Art at the University of Lethbridge in Alberta, Canada.

Young Man has exhibited his work at major museums, including
the Museum of the Plains Indian, the Museum of New Mexico, the
Scottsdale Museum, the Amon Carter Museum (Fort Worth), and the
Museum for Arts of Indian America (Alberta). He is one of the most
stimulating of the young Indian painters.

"My somewhat unusual educational experience has given me a
reinforced perspective of myself as an Indian artist. While my being
Indian was of some trade value in my acceptance in a foreign

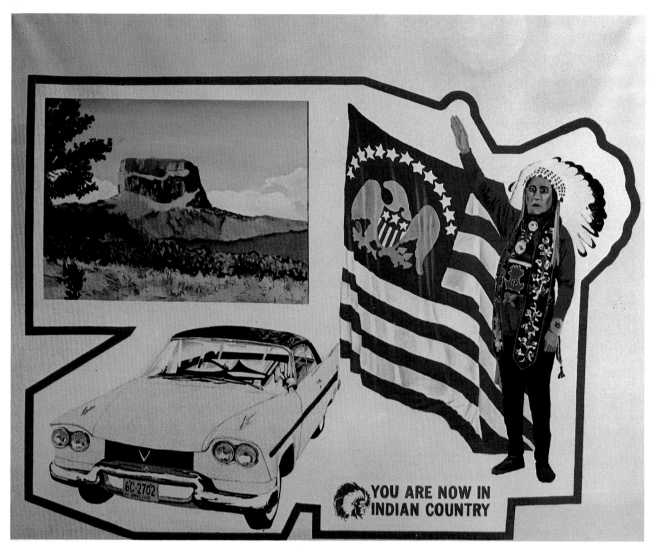

Alfred Young Man: *"The Vacation,"* 1977; acrylics on canvas; 48 × 60 in.;
courtesy of the artist.

country, I found that I was tested mainly as a man, a person, a
contemporary American. As for my art, they didn't know where I
was coming from in terms of my Indianness. And while it naturally
reflects the experiences I have lived and the exposure I have had to
non-Indian ideas and technology, no one can take away the increased
respect I have gained for my own cultural background, a respect
which was originally instilled in me as a child back home on the
reservation by my aunts and uncles—Indian beliefs, feelings, that are
not only hard to explain but, I believe, beyond a certain point,
shouldn't be explained. And while there are certain things Indian
that I will never reveal through my paintings, I feel that my
statements are Indian; and while they are not like those of older

Indians they are as real and honest a reflection of me as an Indian in my time as they were of them in their time. Despite all my non-Indian experiences, my paintings are more ethnocentric than ever. I do not believe that Indian art must stagnate at any one point in the past—if it comes out of an Indian mind it can't be anything other than Indian art."

Alfred Young Man: *"Black Sun,"* 1973; *acrylics on canvas; 30 × 48 in.; courtesy of the artist.*

Alfred Young Man: *"Homage to the Maker of the Buffalo Spirit,"* 1978; *acrylics on canvas; 42 × 48 in.; courtesy of the University of Lethbridge, Alberta.*

Broder, Patricia Janis. *Bronzes of the American West.* New York: Harry N. Abrams, 1977. An excellent survey of the romantic bronzes of the West, with a good chapter on Native American sculptors.

———. *Hopi Painting: The World of the Hopis.* New York: A Brandywine Press Book, 1978. An elaborate and excellent survey of Hopi pictorial art from its origins to the present day, including the works of the leading contemporary Hopi artists.

Brody, J. J. *Indian Painters and White Patrons.* Albuquerque, N.M.: University of New Mexico Press, 1971. One of the first polemics in the field of Indian painting, which presents, beyond its fascinating argument, some rare critical views of Indian art from the standpoint of a writer with a grasp of both Indian anthropology and world painting. Brody's premise is that Indian painting is not in fact Indian painting but a twentieth-century decorative form made essentially for Anglo patrons.

Cinader, Bernard. "Art of the Woodland Indians." Introduction for *Contemporary Native Art of Canada—The Woodland Indians.* Toronto: Royal Ontario Museum, 1976.

———. "Explorations of Past, Present and Future," *The Indian Trader,* vol. 10, no. 1 (January 1979).

———. "Tradition and Aspiration in Contemporary Canadian Indian Art." In *Contemporary Indian Art—The Trail from the Past to the Future.* Peterborough, Ont.: Trent University Press, 1977. These three articles are invaluable sources of information about the Indian arts of Canada, written by one of the major collectors, commentators, and exhibition organizers of Canada.

Dawdy, Doris Ostrander. *Annotated Bibliography of American Indian Painting.* Contributions from the Museum of the American Indian. New York: Heye Foundation, 1968. The major bibliographic source on the subject of Indian painting.

Dickason, Olive Patricia. *Indian Art in Canada.* Ottawa, Ont.: Department of Indian Affairs and Northern Development, 1972.

Dockstader, Frederick J. *Indian Art in America.* Greenwich, Conn.: New York Graphic Society, 1961. The major source book on the background of Indian arts and crafts in the United States.

Douglas, Frederic H., and d'Harnoncourt, René. *Indian Art of the United States.* New York: Museum of Modern Art, 1941. One of the first general ap-

preciations published in America, in coordination with the first major exhibition of Indian painting in America.

Driver, Harold E. *Indians in North America*. Chicago: University of Chicago Press, 1961. The most scholarly approach to Indians from a topical standpoint.

Dufrenne, Mikel. *The Phenomenology of Aesthetic Experience*. Evanston, Ill.: Northwestern University Press, 1973. An exceptional summation of the decade of modern philosophy that started with Sartre and ended with Dufrenne's application of existentialism to phenomenological aesthetics.

Dunn, Dorothy. *American Indian Painting*. Albuquerque, N.M.: University of New Mexico Press, 1968. The single historical prospectus on native American painting in the Southwest and Plains areas from the viewpoint of the founding director of the Studio in Santa Fe, where many important Southwest Traditional painters were trained.

———. "America's First Painters." *National Geographic Magazine*, March 1955, pp. 349–78. A good popular treatment of Indian painting that reached a mass audience and presented a double-page color spread of Blackbear Bosin's "Prairie Fire" that made a strong impression.

Dutton, Bertha. *Sun Father's Way*. Albuquerque, N.M.: University of New Mexico Press, 1963. An important book on Southwest tradition by one of the most important curators (retired from the now defunct Museum of Navajo Ceremonial Art, Santa Fe).

Ewers, John Canfield. *Plains Indian Painting*. Palo Alto, Cal.: Stanford University Press, 1939. The pioneer work on the subject of hide painting by one of the most active educators and curators concerned with Indian painting.

Ewing, Robert A. "The New Indian Art." *El Palacio*, vol. 76, no. 1 (Spring 1969), pp. 33–39. The director of the Museum of New Mexico takes on an argument similar to Brody's views of the emergence of true Indian painting with the Contemporary artists from the Institute of American Indian Arts, commencing about 1962.

Farb, Peter. *Man's Rise to Civilization, as Shown by the Indians of North America from Primeval Times to the Coming of the Industrial State*. New York: E. P. Dutton & Co., 1968. Though it is possible that anthropologist Farb does not succeed in making his complex premise about the evolution of social structures stick, he has nonetheless written what is probably the best general analytical approach to the cultural and social structure of the American Indian.

Fewkes, J. Walter. "Hopi Kachinas, Drawn by Native Artists." U.S. Bureau of American Ethnology, Annual Report, no. 21 (Washington, D.C., 1903), pp. 3–126. The source of the first-known drawings by American Indians produced on commission.

Hess, Hans. *How Pictures Mean*. New York: Pantheon Books, 1974. An exciting and radical book concerned with the way in which artists speak through their paintings.

Hewett, Edgar L. *Ancient Life in the American Southwest*. Indianapolis: Bobbs-Merrill, 1930. Another pioneer work, which formulated from an aesthetic standpoint a firsthand view of Indian art of the Southwest.

Highwater, Jamake. *Fodor's Indian America: A Cultural and Travel Guide.* New York: David McKay Co., 1975. The author's synthesis of culture and geography as a guide to America's Indians.

————. *Song from the Earth: American Indian Painting.* Boston: New York Graphic Society, 1976. The author's survey, history, and evaluation of Native American painting in North America, commencing with pre-Columbian antecedents and continuing through the fruition of the Traditional School of Indian painting and concluding with the current trends of Contemporary art idioms.

Introduction to American Indian Art, to Accompany the First Exhibition of American Indian Art Selected Entirely with Consideration of Esthetic Value. Glorieta, N.M.: Rio Grande Press, 1970. Reprint of two scarcely remembered volumes first published in 1931 for the Exposition of Indian Tribal Arts in New York, consisting of various brief essays, each by an outstanding early authority on the subject, plus an excellent, very complete bibliography. Three essays are of particular value owing to their immediacy in depicting developments in Indian painting by authors who had personally witnessed the evolution: "Introduction to American Indian Art" by John Sloan and Oliver La Farge; "Fine Art and the First Americans" by Herbert J. Spinden; and "Modern Indian Painting" by Alice Corbin Henderson, the major source from which most subsequent data on the San Ildefonso School (1918–30) were drawn.

Jacobson, Oscar Brousse. *Kiowa Indian Art.* Nice, France: C. Szwedzicki, 1929. The first folio of Indian art, organized by the University of Oklahoma art department chairman as part of his work with the Kiowa Five.

La Barre, Weston. *The Peyote Cult.* New York: Schocken Books, 1969. The foremost study of peyotism among Mexican and American Indians.

Langer, Suzanne K. *Mind: An Essay on Human Feeling.* Vol. 1. Baltimore: Johns Hopkins Press, 1967.

————. *Problems of Art.* New York: Charles Scribner's Sons, 1957. Two works concerned with Langer's theory of expressive form, which grew out of her earlier works *Philosophy in a New Key* and *Form and Feeling.*

Leach, E. R. "Aesthetics." From *The Institutions of Primitive Society, a Series of Broadcast Talks.* London: Basin Blackwell, 1956. An important lecture in comparative aesthetics from the standpoint of primal art by a renowned lecturer in anthropology at Cambridge University.

Leftwich, Rodney L. *Arts and Crafts of the Cherokee.* Cullowhee, N.C.: Land-of-the-Sky Press, 1970. A brief profile of the arts of the Eastern Band Cherokee, North Carolina.

Mallery, Garrick. *Picture Writing of the American Indians.* New York: Dover Press, 1972. A reproduction of the classic study from the U.S. Bureau of American Ethnology, Annual Report, No. 10.

Patterson, Nancy-Lou. *Canadian Native Art, Arts and Crafts of Canadian Indians and Eskimos.* Toronto: Collier-Macmillan Canada, Ltd., 1973.

Petersen, Karen Daniels. *Plains Indian Art from Fort Marion.* Norman, Okla.: University of Oklahoma Press, 1971.

———. *Howling Wolf.* Palo Alto, Cal.: American West Publishing Co., 1968. Two essential studies of the Fort Marion painters.

Read, Herbert. *Icon and Idea.* New York: Schocken Books, 1972.

———. *The Philosophy of Modern Art.* New York: Horizon Press, 1953. Two works by a leading spokesperson for contemporary Anglo art.

Silberman, Arthur. "Early Kiowa Art." *Oklahoma Today*, vol. 23, no. 1 (Winter 1972/73).

———. "Tiger." *Oklahoma Today*, vol. 21, no. 3 (Summer 1971).

Smith, Watson. "Kiva Mural Decorations at Awatovi and Kawaika-a." *Peabody Museum Papers*, vol. 37 (Reports of Awatovi Expedition No. 5). New Haven, Conn., 1952.

Snodgrass, Jeanne O. *American Indian Painters: A Biographical Directory.* New York: Museum of the American Indian, Heye Foundation, 1968. An assembly of data on virtually every Indian painter in the United States with biographical data and historical notes.

———. "American Indian Painting." *Southwestern Art*, vol. 11, no. 1 (1969). A brief and concise history of the subject by one of the major researchers in the field.

Southwest Indian Art. Tucson, Ariz.: University of Arizona Press, 1960, supported by the Rockefeller Foundation. A report to the Rockefeller Foundation covering the activities of the first exploratory workshop in art for talented younger Indians, held at the University of Arizona in the summer of 1960.

Tanner, Clara Lee. *Southwest Indian Painting.* Tucson, Ariz.: University of Arizona Press, 1957; rev. ed., 1973. The first full-scale treatment of the history and aesthetics of Southwest Indian painting.

Taylor, Michael. "Faces and Voices." In *Moccasins on Pavement: The Urban Indian Experience, a Denver Portrait.* Denver, Col.: Denver Museum of Natural History, 1979. The catalog for the exhibition of photographs concerned with urban Indians of Denver.

Underhill, Ruth M. *Red Man's Religion.* Chicago: University of Chicago Press, 1965. A contemporary synthesis of its subject.

Warner, John Anson. "Contemporary Algonkian Legend Painting." *American Indian Art Magazine*, vol. 3, no. 3, (May 1, 1978). An exceptionally focused and valuable introduction to the Contemporary styles of various Cree and Ojibwa Indian artists.

———. *A Cree Life: The Art of Allen Sapp.* (Coauthored with Thecla Bradshaw.) Vancouver, Wash.: J. J. Douglas Publishers, 1977.

———. *The Life and Art of the North American Indian.* London: Hamlyn Publishing Group, 1975.

Zo-Tom. *1877: Plains Indian Sketch Books of Zo-Tom and Howling Wolf.* Introduction by Dorothy Dunn. Flagstaff, Ariz.: Northland Press, 1969. A marvelous set of reproductions of ledger book drawings by two masters of the form.